San Pedro

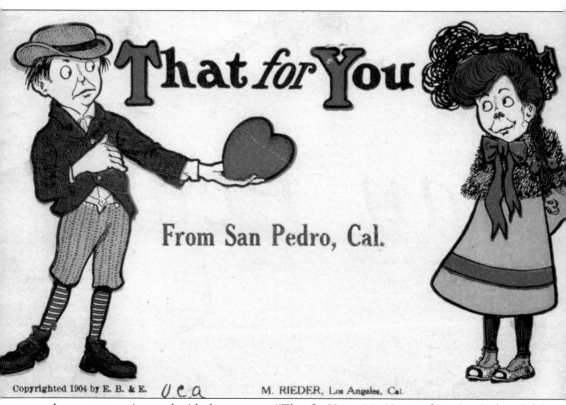

A cartoon greeting card with the message, "That for You—My Heart—from San Pedro, Cal."
(© 1904 by E. B & E.—M. Rieder.)

ON THE FRONT COVER: This is a great view of downtown San Pedro looking north on Beacon Street in the 1930s. The house located in the immediate foreground is the present site of a U.S. post office. The area north of that was being used as a car rental lot in those days.

ON THE BACK COVER: The San Pedro Elks Lodge was founded on June 5, 1905, and the first meeting was held at the old Masonic Hall on Beacon Street until their own facility was built. Another memorable event for the lodge was the formation of a band, which became widely known throughout California. In this view, only a small portion of the band can be seen with their banner at an unknown location.

POSTCARD HISTORY SERIES

San Pedro

Joe McKinzie

ARCADIA
PUBLISHING

Published by Arcadia Publishing
Charleston SC, Chicago IL, Portsmouth NH, San Francisco CA

Printed in the United States of America

Library of Congress Catalog Card Number: 2006933253

For all general information contact Arcadia Publishing at:
Telephone 843-853-2070
Fax 843-853-0044
E-mail sales@arcadiapublishing.com
For customer service and orders:
Toll-Free 1-888-313-2665

Visit us on the Internet at www.arcadiapublishing.com

This book is dedicated to Martha, my wife and proofreader, who just retired after 36 years of teaching. I would have been lost without her help.

CONTENTS

ACKNOWLEDGMENTS

Before I finished my last Arcadia book, *San Pedro Bay*, I was sure another book was needed on the town of San Pedro itself. While the bay book examined aspects of the waterfront, this book looks at the community. It does not claim to be a complete history of San Pedro. On the contrary, it contains small "snippets" of history resurrected by postcard images.

A secondary reason for this book is that San Pedrans have been known for pride in their community, much of that instilled by immigrant parents who brought their sense of dignity and honor from other regions of the world.

My old photograph postcard collection opened for me many historic places and events related to San Pedro's people. But simultaneously the cards limited my explorations since I have only gone where the postcards haven taken me. (I met many photographers and San Pedrans that have great photographs that aren't postcards.)

I need to thank the many people who are members of the San Pedro Bay Historical Society, of whom I have been asking many questions over the past year to gather bits of information. Also I would like to especially thank the two people I quizzed the most, Al Bitonio and Matty Domancich. Both of them are walking encyclopedias about the history of San Pedro.

Unless otherwise indicated, all images in this book are from the author's private collection of photograph postcards.

INTRODUCTION

This place called San Pedro has become home to many diverse immigrant ethnic groups. It is an enormous and great world port, a small town of quaint neighborhoods, a former city, and now a portion of the sprawling metropolis of Los Angeles. San Pedro can be defined in many ways. Ella Ludwig, one of the early historians of the Los Angeles Harbor District, wrote some elemental geographical notations:

> About halfway between Point Conception and the Mexican boundary, in latitude thirty-three degrees, forty-two minutes, and fourteen seconds north and longitude one hundred eighteen degrees, seventeen minutes, eleven seconds west is a beautiful, crescent shaped bay, measuring fifteen or sixteen miles from horn to horn. From the apex of the crescent, or near to it an estuary, called by the pioneers, "the creek," runs into the land a league or more: of this creek much more anon. From the inland shore rises a low, rather struggling plain or valley where today, the city of San Pedro lies . . . it stretches away into a beautiful rolling mesa . . . or as geologists call the entire place, together with the city and the surrounding country, the San Pedro Hills.

Native Americans inhabited these San Pedro hills, bluffs, and valleys until European immigrants started occupying the land. The most well known native group of people was the Suang-na. When the Mission San Gabriel was established, most Native Americans in the area became known as Gabrielinos. Gradually Spanish Californians with land grants settled on large tracts. Juan Jose Dominguez was one such grantee, whose holdings included the Palos Verdes Peninsula.

After Juan Jose's death and the physical absence of heirs, the executor and caretaker of the land granted grazing rights to Jose Dolores Sepulveda. With the advent of Mexico's independence from Spain, and Alta California's long period of governmental neglect, the controversy over the ownership of lands dragged on for decades. Meanwhile families living on the land grew and cattle multiplied. Finally, in 1846, Gov. Pio Pico confirmed the Sepulvedas' right to own the land.

In the early 1800s, land was measured in terms of *varas*, poles, and leagues. Ships off-loading cargo at San Pedro used a piece of land for traffic at the boat landing. This territory was defined and protected in 1846 by Mexican governor Pio Pico when he finalized the Sepulvedas' land ownership. The decree required the owners to leave free "500 *varas* square" (44.25 acres) at the port of San Pedro. Pico's decree also set aside land for future military use that was 500 *varas* square or 44.25 acres for public access near the bluff where the Hide House was located. This area eventually became part of the Fort MacArthur Military Reservation.

During this time of neglect from Spain and Mexico, trading was conducted under crude conditions at the port of San Pedro. In 1822, two Englishmen built a warehouse for trading hides and tallow. Within a few years, the concern encountered financial problems and was sold to San Gabriel Mission. In 1834, as the missions were secularized, Abel Stearns acquired Hide

House and renovated it into Casa de San Pedro. This *varas square* of land principle continued to be respected when the U.S. government took it over in 1848. Then in 1888, Pres. Grover Cleveland declared it a military reservation. In 1914, the reservation became known as Fort MacArthur, named in honor of Lt. Gen. Arthur MacArthur, a military leader in the Spanish-American war, a governor of the Philippines, and the father of the future general of the army, Douglas MacArthur.

In 1882, the railroads extended from Los Angeles to Timms Landing in San Pedro. The port village had grown into a thriving community of 1,400 people by 1888. On February 25, 1888, an election was held on incorporation, with 145 votes for incorporation and 57 against. So on March 1, the City of San Pedro was officially incorporated, encompassing primarily the old downtown business district. The same year a community to be called Town of San Pedro Harbor was proposed for the Point Fermin area. But the point was located an inconvenient two and a half miles from San Pedro City, and this proposal was scrapped.

This incorporated City of San Pedro actually existed for no more than 21 years (1888–1909). In 1899, San Pedro was chosen as the place for the deepwater port for the Los Angeles area. The leaders of the City of Los Angeles saw it was in their best interest (financially) to annex the port and the harbor areas but had to convince the reluctant independent San Pedro and Wilmington that it would benefit them. Frustrated by waiting for a decision, Los Angeles purchased a long and narrow swath of land, the "Shoestring Strip," that connected then-South Los Angeles to Harbor City and threatened to build a new port in Harbor City if San Pedro and Wilmington would not acquiesce to annexation. Finally, August 28, 1909, was the official date of consolidation, with the City of Los Angeles annexing the City of San Pedro and Wilmington.

Remaining a constant influence on the development of the port town was Fort MacArthur, which was comprised of three parcels of land: the original 500 *varas* square, later known as the Middle Reservation; an area on Point Fermin, later known as the Upper Reservation; and a small plot on Terminal Point. By 1919, the army had constructed housing and headquarters in the Mission Revival and California Craftsman architectural styles on the Middle Reservation, which remains today. The 1st Coast Artillery Company was quartered at Fort MacArthur in 1917. During World War I, Fort MacArthur guarded the harbor and served as a training and staging area for army units departing for the European theater.

In March 1933, the Long Beach earthquake was an event that shook the entire Los Angeles area, including San Pedro. All the schools suffered damage, requiring classes to be held in tents or temporary bungalows. The high school was so damaged that a new one had to be built. Many early San Pedro buildings had their ornate trim and cornice work removed for public safety. One of the most visible changes in the downtown business district was the removal of the clock tower on the Bank of San Pedro.

Another geological event of the earth's movement also happened in San Pedro. A portion of Paseo del Mar out at Point Fermin, from just west of Carolina Place to where it connected to Pacific Avenue, started to sink. Small cracks in the surrounding land began to appear in 1929 and grew slowly for many years. Because of this slow earth movement, most of the homes in this area were moved to other locations or torn down during the 1930s. By the 1940s, over six acres had suffered major land movement and the sinking was becoming a classic textbook example of geological sump. Today only broken streets and sidewalks remain where people used to live and now local residents refer to the area as Sunken City.

A regrettable part of San Pedro's history was the demolition of historical places like the Carnegie Library Building and the Gaffeys' La Rambla Hacienda in the 1960s. Then there was the Beacon Street Redevelopment project of 1971. Its grandiose, ill-fated plans leveled those early well-built structures of old San Pedro for an unmet promise. Some of the lots remained empty for over 35 years.

One

DOWNTOWN BUSINESS DISTRICT

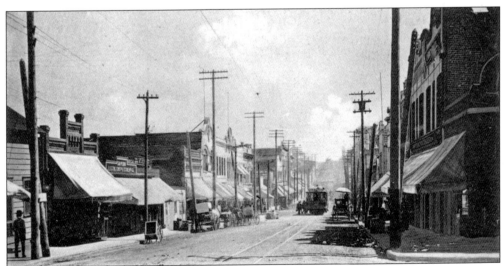

This 1903 postcard, the oldest in the book, is of Beacon Street looking south from the corner of Fifth Street with horse-drawn carriages parked on both sides of the unpaved dirt street. One of the electric-powered streetcars that first started service in January 1903 is picking up passengers.

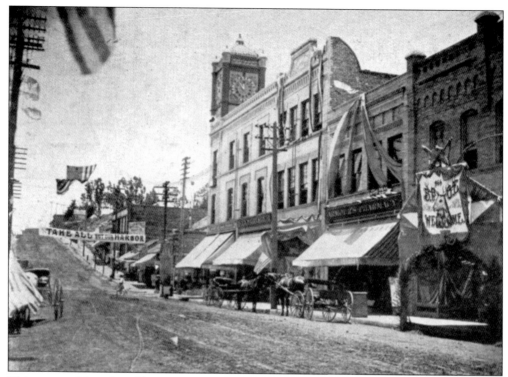

This postcard has the oldest postmark, September 14, 1905, of any in this book. An anti-consolidation banner is strung across the unpaved dirt streets of Beacon Street at Sixth Street. A banner for the newly established BPOE 966 (Elks Club) in San Pedro hangs on the front of the Masonic Hall. The first meeting was held on June 5, 1905, in the old Masonic Hall next door to Armour's Pharmacy.

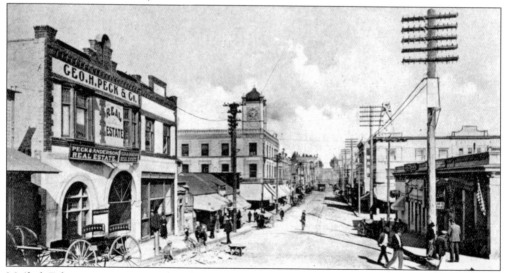

Mailed February 23, 1906, this image looks north along Beacon Street, which is unpaved and all dirt, where there are workers doing some excavating work in front of the two-story building of George H. Peck and Company. There are no motor vehicles in town, only horse-and-buggies and wagons.

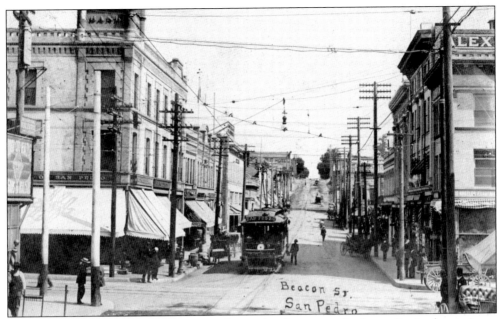

This postcard, mailed in August 1907, shows the downtown business district becoming a modern 20th-century city. The street may still be dirt and there are no cars in town yet, but the city has electricity, telephone service, electric streetcars, and a single streetlight at the intersection of Sixth and Beacon Streets.

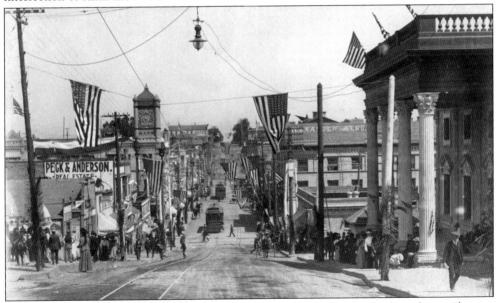

A festive July in 1908 on Beacon Street is marked by flying flags, palm branches, and many people out and about. In the right foreground, there is a line of people waiting to get in to tour the new city hall building with the colossal pillars. Dozens of flags with only 46 stars are hung all along the dirt street, and the power poles have palm branches tied to them for decoration. Streetcars make their way down the center of the street as horse or streetcar was the only mode of transportation of the day. The town of San Pedro is growing as seen by the developer's sign, Peck and Anderson Real Estate, on a building on the left.

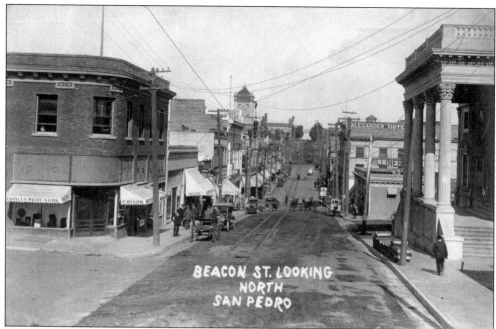

This is a view from Seventh Street looking north along Beacon Street about 1910. The tracks from the discontinued streetcar service have not been removed, nor has the dirt street been paved. Note a pile of water pipes that are stacked in front of the city hall building waiting to be installed. Also, the number of horse-drawn wagons and motor vehicles are still about equal in numbers.

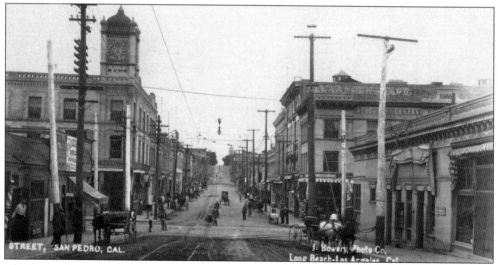

The Bank of San Pedro, with its clock tower on the left, and the Alexander Hotel Building, on the right, are a few of the many businesses on Beacon Street around 1910. The sidewalks are concrete, but there is no need to pave the dirt street since there are no automobiles, just horse-drawn buggies.

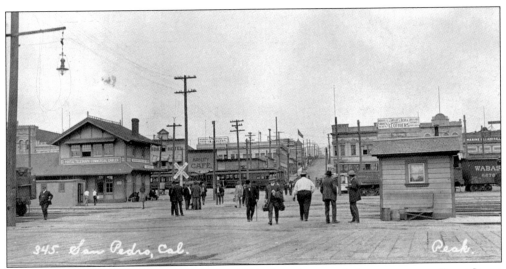

Steps away from the docks of the harbor, *c.* 1910, there is a good view west across Front Street (now Harbor Boulevard) and up Fifth Street (west) as people move towards the rails or away towards town. On the left side is the old Southern Pacific Railroad freight depot with Postal Telegraph and Commercial Cable, a two-story frame building. Upon closer look at some ads and storefront signs among the pedestrians and horses there are Harbor Hotel, Bay City Café, Marine Hardware Company, Ship Chandlers, Bluff Brothers Clothiers (boats, shoes, hats, dry goods, trunks, and suitcases), and Marine Billiard Hall. St. Francis Hotel, near the intersection of Fifth and Palos Verdes Streets and marked by the flag on top of their building, was once considered the best family hotel in town.

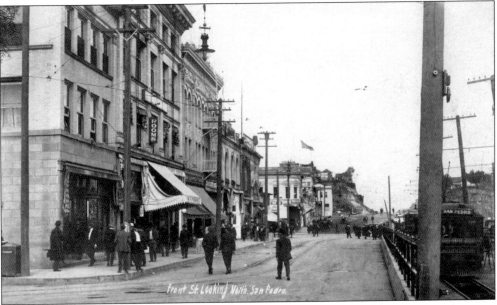

Here is a photograph postcard of the view of Front Street, one block east of Beacon Street, which also looks north past Fourth Street quite clearly. There are several buildings and houses seen on top of the distant hill (Nob Hill) that still had to be moved or demolished before the rest of the hill could be removed. From this view, the red car trains can be seen near the downtown business area (right foreground).

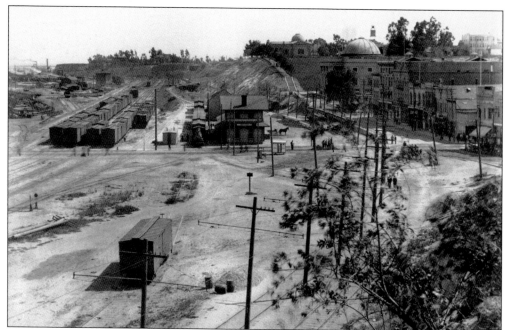

In 1881, the Southern Pacific Railroad extended its tracks from Los Angeles to San Pedro but no depot or yards were built then. As shipping increased in the harbor over the years, the railroad slowly added more track and buildings. To accommodate the development of the new harbor, tracks and buildings were moved or relocated several times. The exact date that the railroad yards were established is unknown, but it happened somewhere between 1881 and 1900. The railroad depot in this photograph was built between 1898 and 1902. This building was demolished in 1919 because track realignment, and a new building was built one block north of the original site.

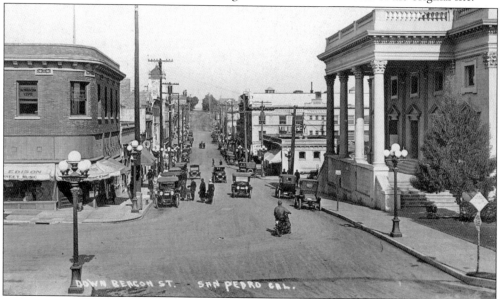

By the late 1910s, most of Beacon Street had been paved. In the distance only one horse-drawn wagon can be seen on the street where motor vehicles now dominate. The old streetcar tracks are gone, but modern streetlights have been installed.

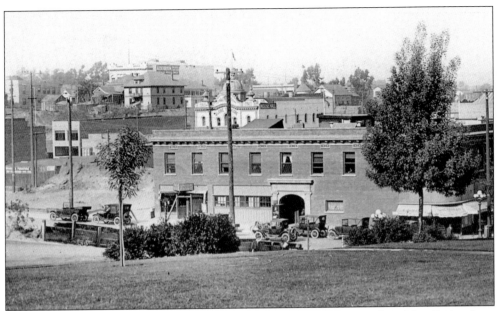

This postcard, mailed on September 15, 1918, shows the hilly geography of San Pedro from Plaza Park looking toward the brick A. P. Ferl Building that was on the northwest corner of Beacon and Seventh Streets. The office of the *Daily Pilot* newspaper is in the left corner of the building next to the empty lot. Beyond it, in the center of the photograph, is the white elaborate architecture of the very popular, domed-roof Globe Theatre. The large building in the distance is the Auditorium Theater, which advertised first-class musicals and comedies.

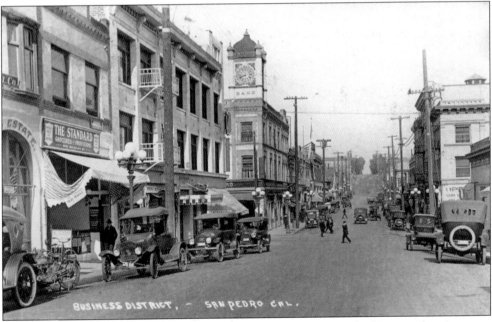

This postcard, mailed May 10, 1919, offers a view of Beacon Street looking north as it crosses Sixth Street. This was considered to be center of the main business district with the Bank of San Pedro and its ornate clock tower. This busy street is lined with cars and not a horse-and-buggy to be seen.

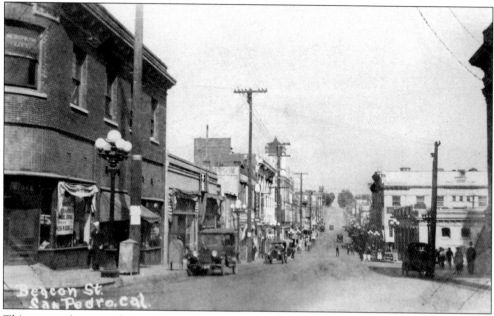

This postcard was mailed in 1921 with the short message, "To my Ruby, Many blissful wishes your L.E.R." A sailor strolls in front of the A. P. Ferl Building, which now has a music store on the ground floor. There are many more pedestrians on Beacon Street than there are motor vehicles on this day. Besides the Ferl Building, other businesses along this street were tailors, Peck and Anderson, an electric store, and Bank of San Pedro.

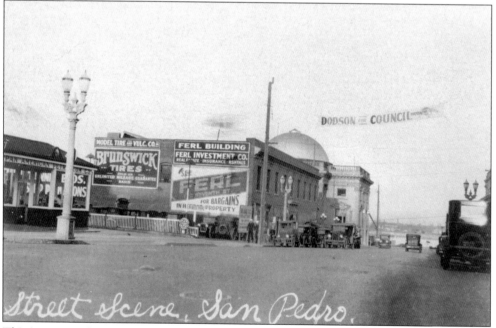

This is a view of downtown San Pedro in the 1920s with its multitude of advertising signs on buildings and storefronts. This photograph is looking east, or towards the harbor, from Seventh Street and Palos Verdes Streets. Among the vintage trucks and cars are two sailors walking the street, which was a common sight when the fleet was in town.

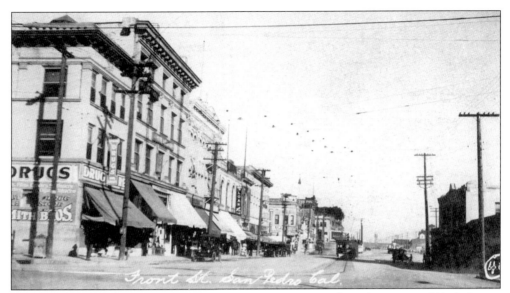

A *c.* 1922 photograph postcard looks north along Front Street from the corner of Sixth Street. This was the first row of businesses that a visitor to the harbor encountered in the early days. It was also the hub of transportation for residents in and out of San Pedro by streetcar as seen traveling south in this photograph. There happens to be only a few cars parked on this usually busy street.

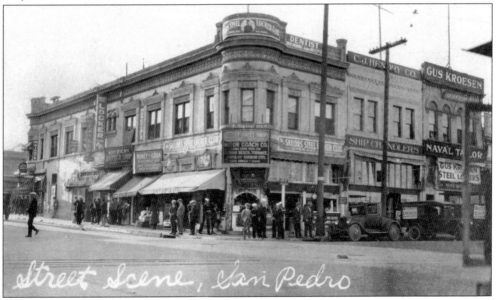

The port was busy, as seen in this *c.* 1920s photograph of the corner of Fifth Street at Harbor Boulevard (then called Front Street). This was a junction of travel between the city of Los Angeles and the port. A sign above the corner states, "Motor Coach Co. Buses leave here for Redondo Beach, Torrance, Lomita and Harbor City, Santa Monica, Venice." Some of the legible signs of the businesses include, from left to right, Pacific Laundry Company, American Barbershop, Money-to-Loan, Liberty Sweet Shop, Motor Coaches, Company Dentist, Sailors Steel Locker Club, C. J. Hendry Company Ship Chandlers, and Gus Kroesen Naval Tailor. On two vehicles there are campaign signs, "Dodson for Council," another well-known name in early San Pedro.

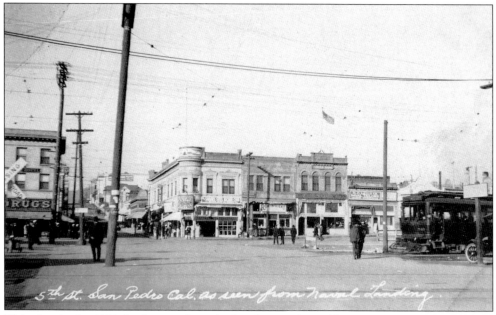

This view in the 1920s looks west from the ferryboat and naval landing to the businesses along Front Street that go up Fifth Street to the Auditorium Theater. Fifth Street was the only public access across all the railroad tracks that paralleled Front Street.

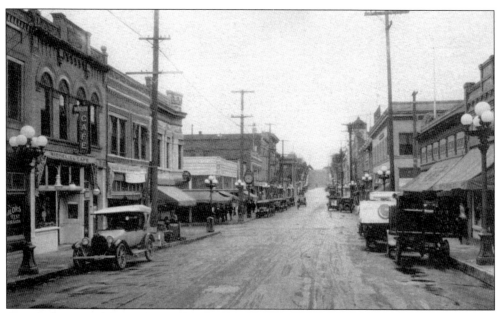

On a dark, rainy afternoon, paved Beacon Street is still wet as this photograph looks south from the middle of the 400 block towards Seventh Street in the 1920s. Yet south beyond Seventh Street the street is still dirt. On the right side there is a clock standing on Beacon Street near the corner of Fifth Street that marks the time at 3:40 p.m.

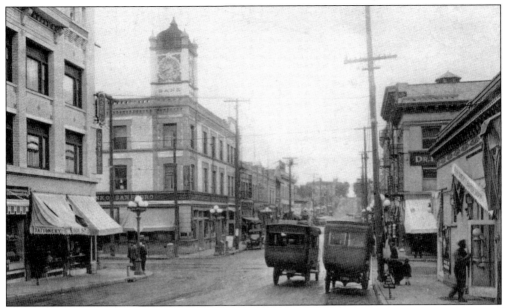

In this 1920s view, looking north up Beacon Street as it crosses Sixth Street, there are two of the early busses that competed with electric streetcars for passenger service. One bus is stopped, apparently picking up riders, as a man enters a barbershop.

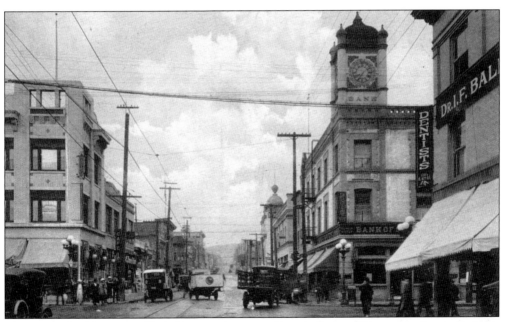

This image looks west up Sixth Street as it crosses Beacon Street. The person that mailed this postcard in the 1920s had an interesting perspective in their message, "This is to show you what San Pedro is like. It is much larger than I expected to find it. It is quite an industrial place. Everything is boats. Batson's have a nice little home here." Prominent businesses on the second floor of each of these corner buildings are dentist offices.

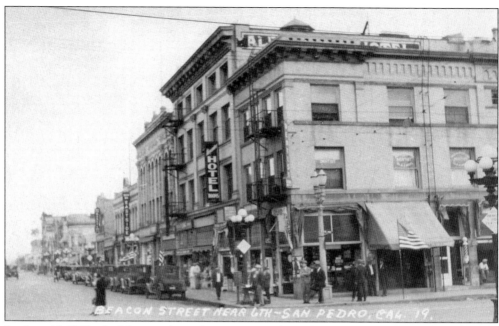

In the mid-1920s, looking north on Beacon Street from the corner of Sixth Street, there are several American flags (with 48 stars) lining the east side of the street. Perhaps something special is happening in town. The street is also full of parked cars even though parking is limited, according to the posted street signs, to only one hour between 7:00 a.m. and 6:00 p.m.

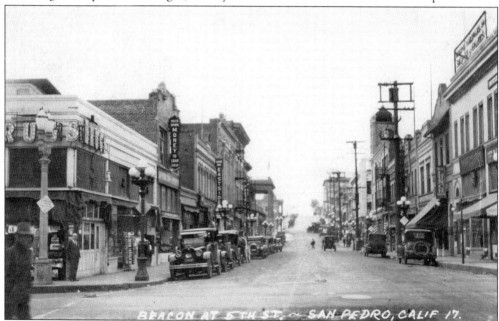

A few years later, in 1924, it is interesting that in this view of Beacon Street, looking south, the only horse-drawn wagon on the street can barely be spotted. It is almost hidden by the multitude of cars parked on the left side of the street and probably most unexpected to be seen at that time, especially when street signs are becoming standard scenery on light poles. These new streetlight poles have diamond-shaped signs that again limit parking to one hour between 7:00 a.m. and 6:00 p.m.

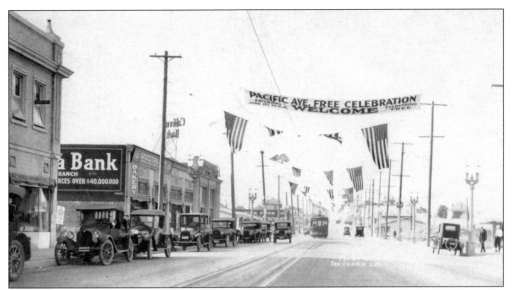

Promotional tricks were present in the 1920s in downtown San Pedro. This 1922 photograph postcard, mailed on March 30, 1923, sent a greeting from the town. Looking south on Pacific Avenue from the corner of Ninth Street, there are dozens of American flags and a banner hanging across the street announcing the "Pacific Ave. Free Celebration Saturday June 17 at 7:30 PM WELCOME Everything Free." The California Bank is in the left foreground with a Point Fermin streetcar moving in the center of the street.

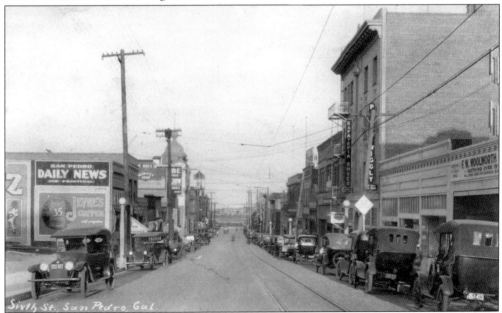

This postcard, mailed on September 27, 1920, of the 200 block on Sixth Street looking east on the left-hand side of the street shows these legible signs: San Pedro Daily News, Jevne's Coffee, Wash-E-Z-Y Soap, and Globe Theatre. On the right side of the street is Hoffman House at 243 Sixth Street, Kafateria Shoes, and a sign for the new business: "F. W. Woolworth Company, Nothing over 15¢, Will open here for business soon, 5¢ 10¢ and 15¢." Any of these buildings managing to survive until 1971 were all demolished that year as part of the Beacon Street redevelopment.

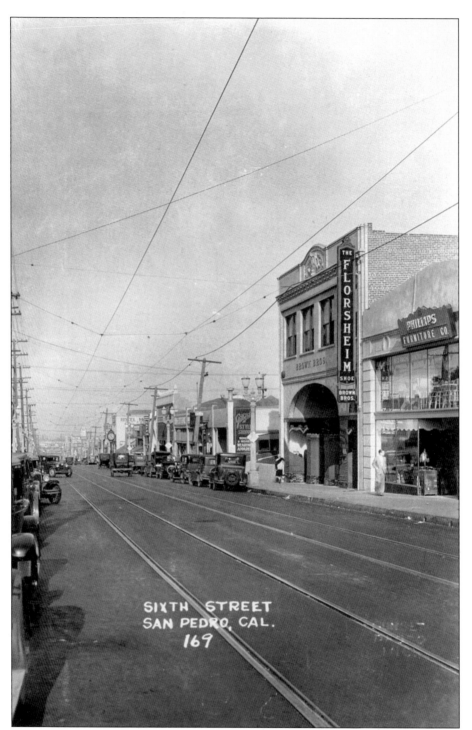

SIXTH STREET
SAN PEDRO, CAL.
169

This is probably a very identifiable section of downtown to any San Pedran since the Brown Brothers Building, the center two-story building, is still at that locale. Not many changes have been made to this south side of the 400 block of Sixth Street since this photograph was taken in 1929. However, streetcar tracks or overhead wires have been gone for decades.

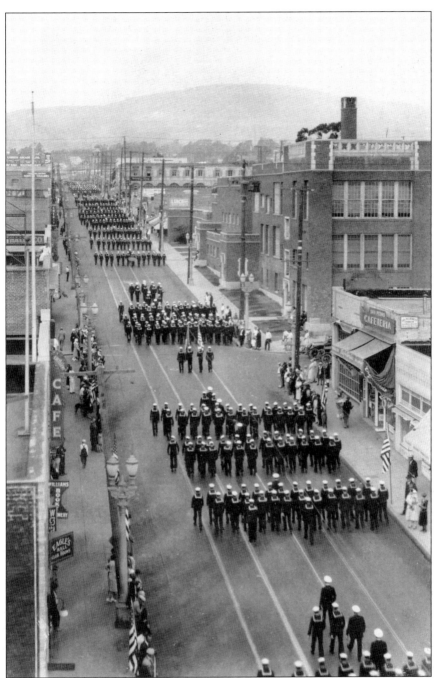

"When the navy comes to town" was not a fabrication as proven in this 1926 photograph of a dress parade of the U.S. Navy on Sixth Street in downtown San Pedro. The large brick building on the right is Fifth Street School, which was closed and demolished in 1927. The locale is now the Municipal Court Building and parking lot at Sixth and Centre Streets. At the lower left, the sign for Williams Bookstore can be seen when it was located at 279 West Sixth Street. Williams Bookstore is presently the oldest established bookstore in the city of Los Angeles.

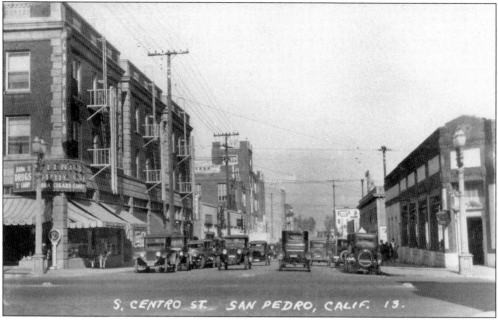

A ground view looking north on Centre Street from the intersection of Sixth Street, around 1926, shows a busy downtown street in San Pedro. The large brick building on the left is the Hotel Cabrillo, which still operates today. The next tall brick building in the distance is Fifth Street School. Upon close inspection, other businesses identified are Hotel Miramar, Flentge Drug Company, and Angeles Hotel. All the buildings on the right side of Centre Street in this photograph have been demolished.

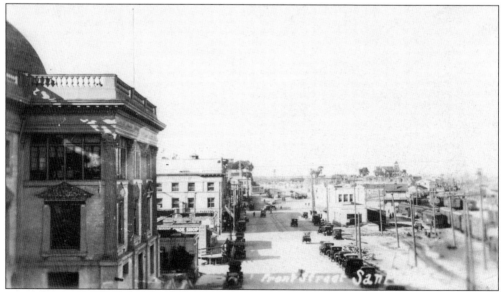

This view looking north on Harbor Boulevard shows the old domed city hall building in the immediate left foreground that was located at Seventh Street between Beacon and Front Streets. To make room for the new municipal building, the old city hall was demolished in 1927. In the distance on the right, on top of what is left of Nob Hill, the tower of the Hotel San Pedro (formerly Clarence Hotel) can barely be seen as the high point of the town's skyline.

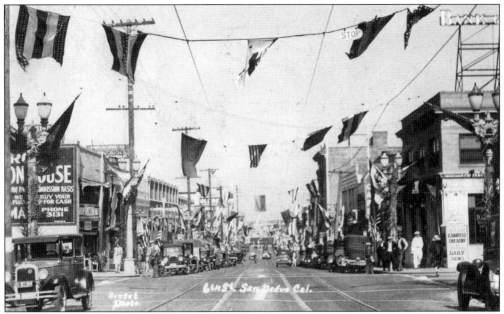

This San Pedro street is crowded with cars, citizens, and sailors. All the flags that are present and waving across Sixth Street indicate festivities. From this Centre Street vantage point, down to the harbor, it looks like the town is getting ready for something. This photograph card was mailed in June 1932 from British Columbia to Denmark, but the writing was illegible. The car in the lower left corner has a 1927 license plate.

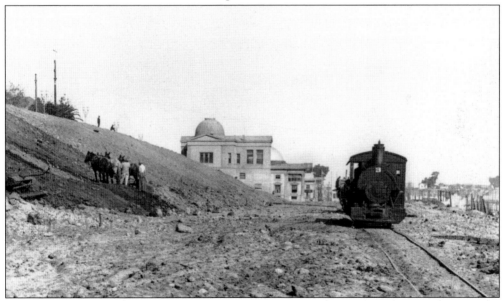

Harbor Boulevard is being improved in this 1924 photograph postcard. It shows two men, with three mules on the side of the hill to the left, in the process of grading the hill that was part of Plaza Park; the work was started in 1923. The work was done between Seventh and Fourteenth Streets by widening and extending Harbor Boulevard south past where the train and tracks are shown. In the background is the domed Carnegie Library in front of the domed city hall building.

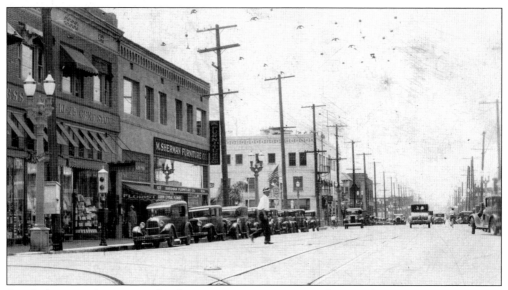

San Pedro was also a town for the visitor or part-time resident in the 1930s as indicated by the message that reads, "Dear Holly, This is near the main drag in this town, we have a cute apartment but will be home March 30. We are having a dandy trip. Love, Alma and Grace." Pacific Avenue is captured in this photograph postcard, sent on March 21, 1930, looking south between Sixth and Seventh Streets with well-known stores like Kress 5-10-25 Cent Store, M. Sherman Furniture Company, and Gordon Florist Shop lining the east side of the busy street. Pacific Avenue remained the "main drag" of town until the late 1960s when shopping malls became popular.

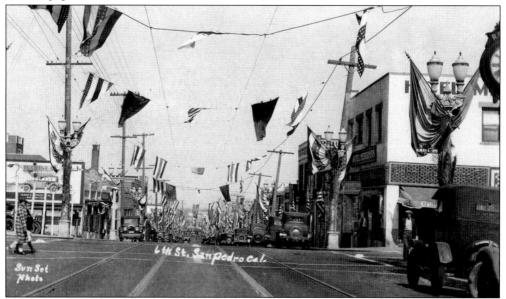

Mailed on September 6, 1931, this photograph depicts the view from Mesa Street looking east to Sixth Street with flags waving high above the streets and carries a message about decorations, "Dearest Sweetheart Of course Baby This was taken when the Burg was all dressed up Love Daddy." The photograph also shows Merrill Music Store and a mix of cars and horse carriages dotting the street. (Sunset Photo.)

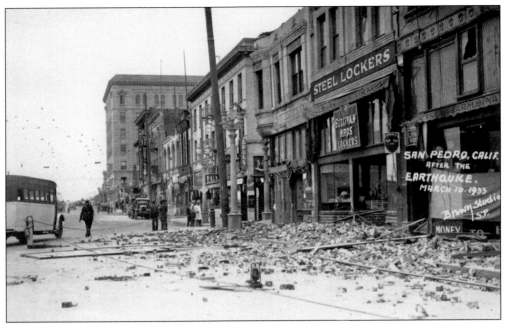

On the afternoon of March 10, 1933, at 5:55 p.m., the Long Beach earthquake occurred with an estimated magnitude of 6.3 affecting the neighboring towns, including San Pedro. This photograph, looking south from the middle of Fourth Street in San Pedro and along Harbor Boulevard, shows piles of broken brick that covered the sidewalks in front of the stores. Two soldiers from Fort MacArthur assist a policeman in roping off the fallen debris from the buildings.

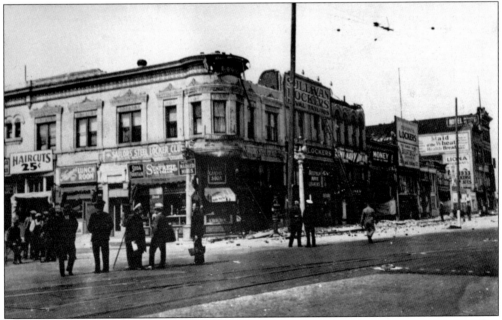

Another photograph looking north from the corner of Fifth Street and Harbor Boulevard in downtown San Pedro captures the damage of the 1933 earthquake. All of the schools in San Pedro suffered damage, requiring all classes to be held in tents and temporary bungalows until repairs were completed.

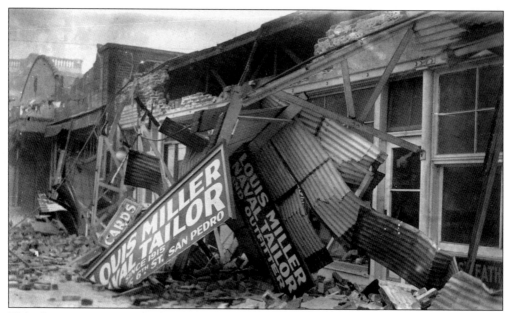

This close-up view captures the severe damage to the facade of the Louis Miller Naval Tailor Shop on Sixth Street. Per the photograph, it had been in business since 1915. This postcard has a message about the earthquake, stating, "You will see sign with cards on it. Well, that was our neon sign. I just escaped that pile of iron & bricks. If I can get a paper at the Time(s) I'll send you one. Mrs. V."

An aerial view from Fourth Street looking south down Harbor Boulevard (old Front Street) gives a good look at the Globe A-1 Flour sign to the left of the Pacific Electric Building in the center of the photograph. The tall structure on the ride side of Harbor Boulevard is the new municipal building, constructed in 1928, which is still standing today.

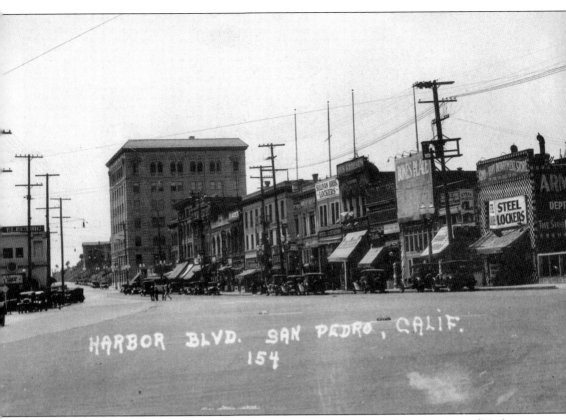

HARBOR BLVD. SAN PEDRO, CALIF.
154

Dominated by the newly finished municipal building two years prior, this 1930 view of Harbor Boulevard shows the multitude of awnings that represented businesses in downtown San Pedro. It is the only building in the photograph postcard that survived the wrecking ball of the 1970s. Some of the not-so-lucky businesses at the time were Hotel Alexander, Sullivan Brothers Lockers, Gus Kroesen Naval Tailor, Milder's, Bones Place, The Front Street Store, Steer Lockers, the Army and Navy Department Store, and finally The Store That Sells For Less.

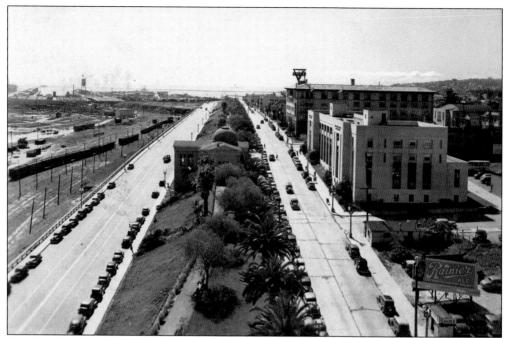

This quite extraordinary bird's-eye view, taken in the 1940s from the upper floor of the municipal building at Seventh Street, looks south with Harbor Boulevard on the left. The Carnegie Library is in the center of the Plaza Park. Across Beacon Street is the post office and customs building and south of that is the YMCA building with its triangular sign piercing the skyline.

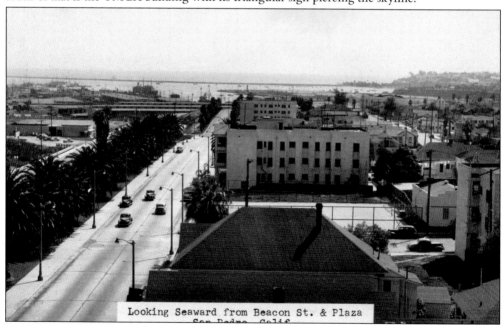

Looking Seaward from Beacon St. & Plaza

This is a great 1940s view from the top of the YMCA building between Eight and Ninth Streets looking south along Beacon Street that ends just past Fifteenth Street. In the distance is the outer harbor and breakwater, and at left, the strip of land densely filled with palm trees, is Plaza Park.

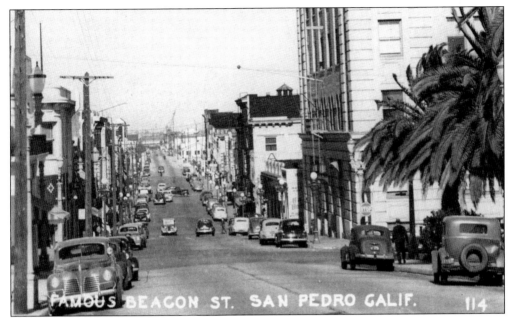

In this 1940s view, streetcars no longer crowd the street, but Beacon Street is still a busy business district as evidenced by all the cars on the street. A corner of Park Plaza can be identified in the right foreground with date palms blowing, as well as the tall municipal building on the right. The rest of Beacon Street, except for city hall, would be demolished in the 1970s Beacon Street Redevelopment Project.

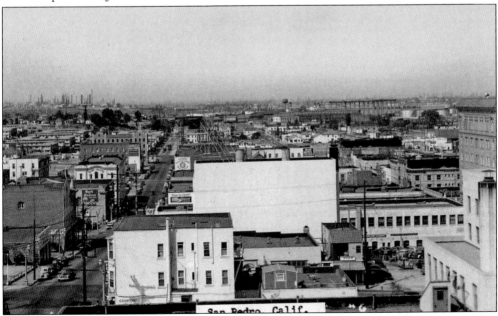

This is the view in the 1940s as seen from the top of the YMCA building that was located at Ninth and Beacon Streets in downtown San Pedro. The large white-walled building in the center is the back of the Fox Cabrillo Theater, and to the immediate left is the smaller Globe Theatre. On the right side, two of the only buildings still standing today can be seen: the corner of the U.S. Post Office building in foreground and behind it the municipal building.

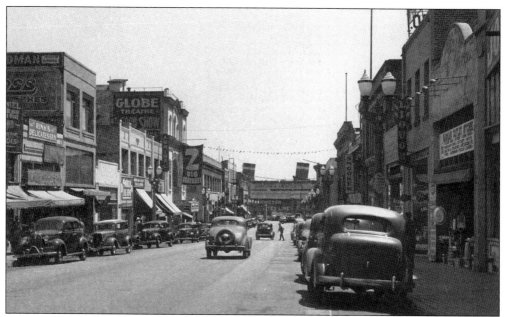

In this view east down Sixth Street, towards the harbor, it looks like the ocean liner *Washington* is blocking the end of the street where the new ferry building would soon be built. This United States Line ship is actually entering the channel to dock, which was a common scene in downtown San Pedro. On the left side of this 1940s photograph, some of the legible signs from businesses are Rinks Delicatessen, M. A. Widman Men's Store, Admiral, Globe Theatre, and the Bank Café. Signs on the right side the street are Snookers and the Liquor and Bargain Outlet Store.

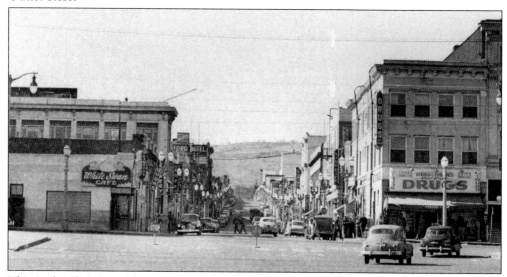

This is the "hustle and bustle" of San Pedro in postwar 1951. This scene is looking west up Sixth Street where it crosses Harbor Boulevard full of cars, businesses, and people. Some of the businesses noted in this photograph are the White Swan Café on the left with the Ford Hotel up the street, the Warner Grand Theater in the distance with the Admiral on the same north side of the street, and the famous Bank Café just behind the popular Hirschman's Cut-Rate Drugs on the right of the street.

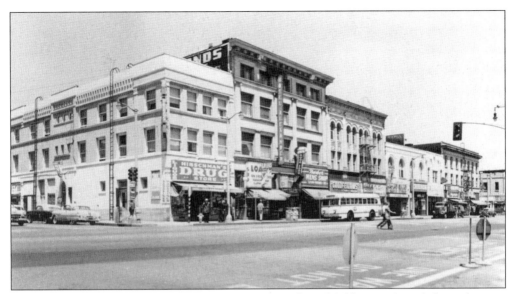

This is a great daytime shot of the 1950 Harbor Boulevard (old Front Street) from the east. Some of the businesses pictured here are Hirschman's Drugs, Loans, Alexander Hotel, Harbor Mens Shop, Tommy's Goodfellows, Mission Smoke House, Getaway, and the Criterion. Many citizens in retrospect regret that this entire block was demolished in 1971 as part of the Beacon Street redevelopment.

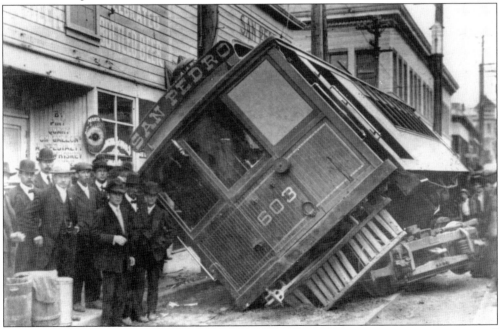

This photograph postcard portrays the incident of Pacific Electric's Car No. 603 running off the narrow-gauge track on Fifth Street between Beacon Street and Harbor Boulevard in 1907. Per newspaper accounts, a broken brake rod caused the car to lose control down the hill before crashing. This car was among the many that were built by Hammond in 1898 for the Los Angeles and Pasadena Electric Railway, which was taken over by Pacific Electric in 1902. This Pacific Electric line ran to San Pedro via Vermont Avenue in Gardena.

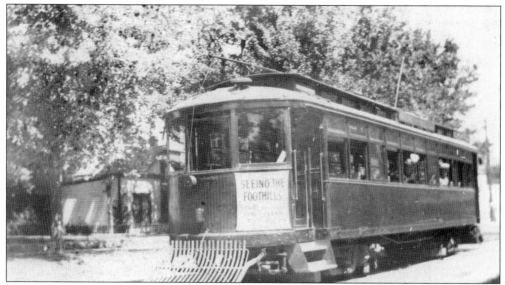

This *c.* 1928 postcard shows a wooden electric streetcar from the Gardena and San Pedro line stopped at an unknown location while passengers can be seen looking out the windows. The front of the car has an advertising sign on it, which states, "Seeing The Foothills. A Day To The Mountains And Return $1.00."

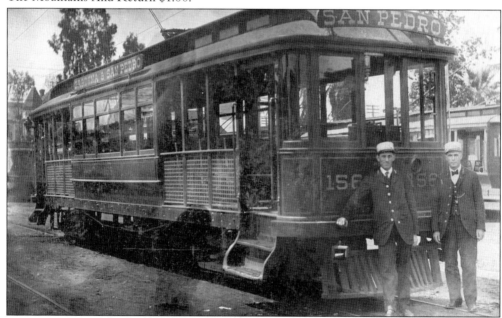

This 1920s photograph shows two conductors posing in front of a San Pedro streetcar. The first Pacific Electric cars arrived in San Pedro on a narrow-gauge track operated by the California Pacific Railway Company. This company was an interurban subsidiary of the Los Angeles Traction Company that replaced the horse-drawn cars George Peck had operating in town. The Pacific Electric came from Los Angeles via Gardena down North Gaffey, around the West Basin and to Front Street. The Pacific Electric Red Car service lasted until 1958 when the LAMTA (Los Angeles Metropolitan Transportation Authority) ordered the rail service to stop due to decreased patronage and replaced the service with busses.

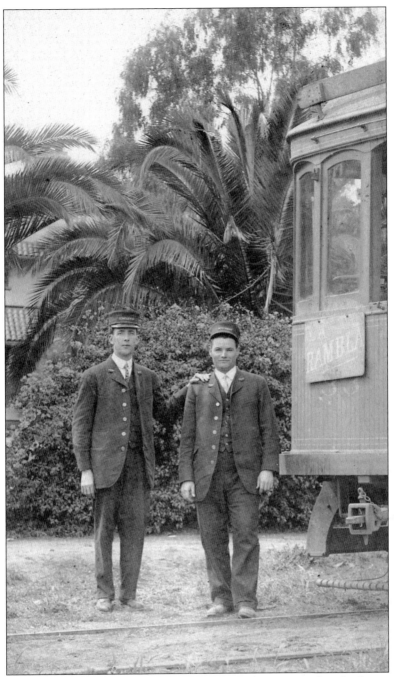

Here is a fine photograph of the conductor and his motor foreman beside the streetcar that ran to La Rambla, a section of San Pedro. In the background, parts of the Gaffey Hacienda can be seen at Third and Bandini Streets, which much later was torn down and replaced by the YMCA when historical preservation was not a community priority. This line was built in 1905–1906 and survived until June 23, 1938. The postcard was mailed on March 12, 1912, with this message, "I will send you this. If you came down here I will show you this place Don't you think it is pretty place? You can use this to keep the rats away."

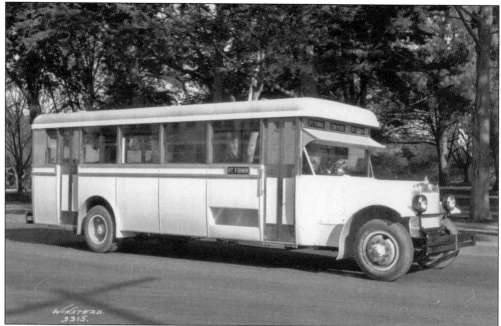

This 1920s postcard depicts a bus of the San Pedro Motor Bus Company, which ran a route from Harbor Boulevard to Point Fermin Park with extended service to Fort MacArthur and Royal Palms—all in San Pedro. The destination of "Pt. Firmin" can be seen on the front of the bus as well as on the side. The spelling of the Point reflects the English, rather than the Spanish, spelling of the place, which is used today. (Winstead.)

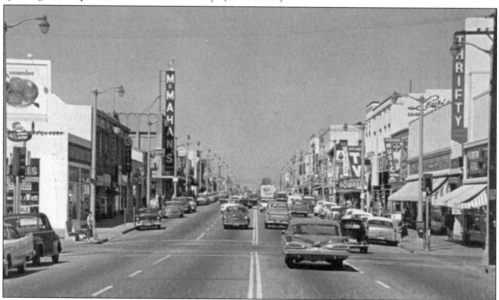

Pacific Avenue, between Sixth and Ninth Streets, had become the main shopping district of San Pedro. A 1959 photograph postcard, looking north on Pacific Avenue past Ninth Street, offers a view of what it looked like. Many stores like Thrifty's, Lewis' Clothing for Women, and music and tire stores line the street. Workers frequented the stores as they changed bus lines on their way home from the canneries, the docks, or from school.

Two

BUILDINGS

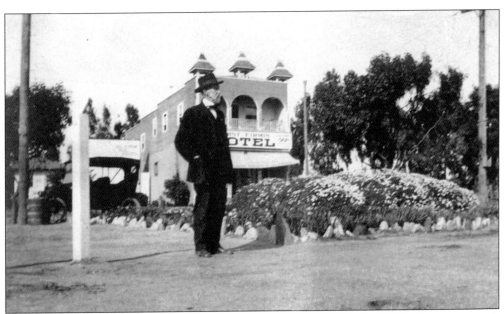

A man wearing a suit and hat stands waiting in front of the Point Firmin (Fermin) Hotel, which was considered to be out in the country in 1915 when this image was taken. It was located in the area of Point Fermin that later would be part of Sunken City.

This is a 1921 photograph of the ferry terminal and navy landing on the docks of San Pedro, which was located at the end of Fifth Street after it crossed Front Street and the railroad tracks. Several people and a sailor next to the hamburger stand appear as if they are waiting for the next ferry.

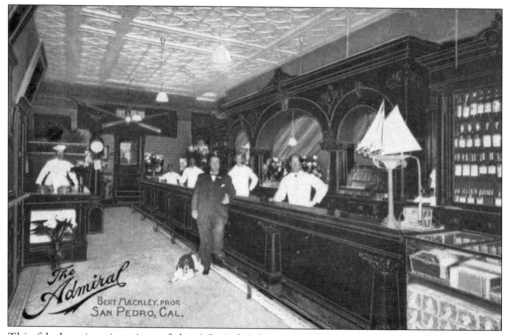

This fabulous interior view of the Admiral Saloon, established on November 6, 1896, and located on Sixth Street with its classic-style bar, foot rail, and ornate tin ceiling, is what people would expect to find in the early 1900s. It was owned by Luke Kelly, a volunteer fireman for the city, who also owned the Criterion Saloon.

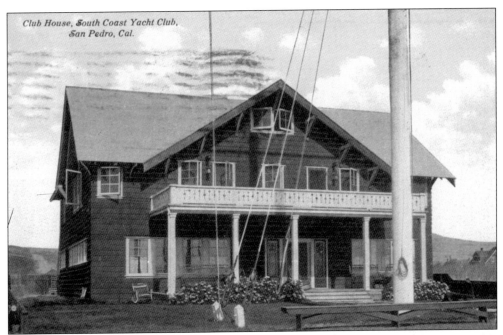

Club House, South Coast Yacht Club,
San Pedro, Cal.

This postcard, mailed in 1911, shows the clubhouse of the South Coast Yacht Club. In 1922, the Los Angeles Yacht and Motor Boat Club joined this organization, and they became the Los Angeles Yacht Club.

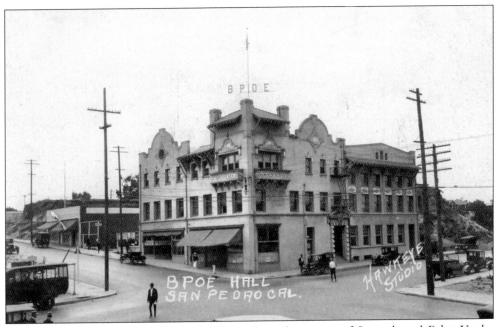

The then-new Elks Lodge BPOE 996, located on the corner of Seventh and Palos Verdes Streets, was dedicated on May 19 and 20, 1911. This was a three-story, 70- by 100-foot brown stucco building. A cupola, replete with arched windows, rose from the roofline on the front corner and formed a cornet with red tiles along the roof edges at intervals. The 1933 earthquake damaged the upper part of the building, and the cupola had to be removed.

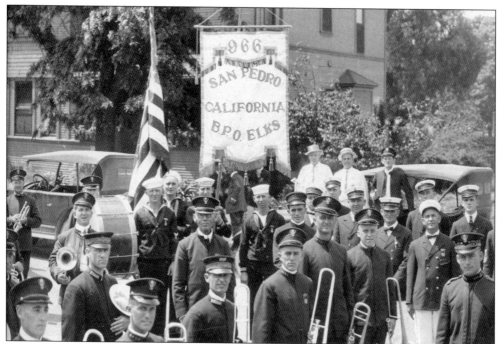

The San Pedro Elks Lodge was founded June 5, 1905, and the first meeting was held at the old Masonic Hall on Beacon Street until its own facility was built. Another memorable event for the lodge was the formation of a band, which was widely known throughout California. In this view, only a small portion of the band can be seen with their banner while at an unknown location.

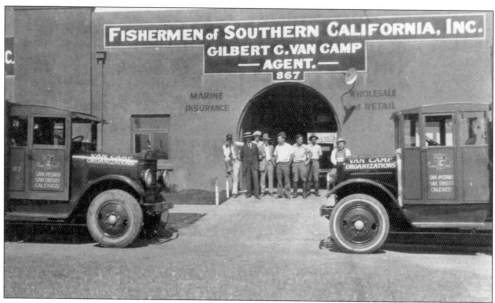

San Pedro Harbor was home to the country's most successful fishing fleet during the 1920s. Van Camp, along with the other canneries on Terminal Island, helped fill the country's demand for canned fish. As some men pose between the trucks, it can be seen that Van Camp had facilities in San Pedro, San Diego, and Calexico from the advertising on the vehicle's doors.

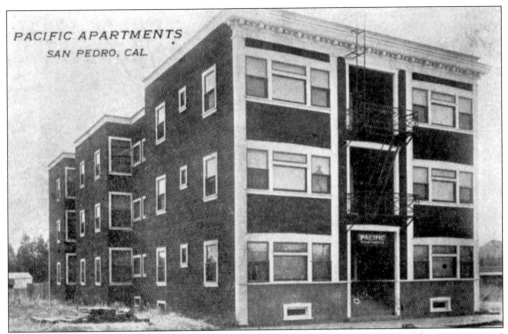

This is the Pacific Apartments in the 1920s, at 1318 Pacific Avenue, which is still being used as an apartment building today. The structure has the same trim and cornice work and ornate metal fire escape. The brick walls have now been covered by gray stucco.

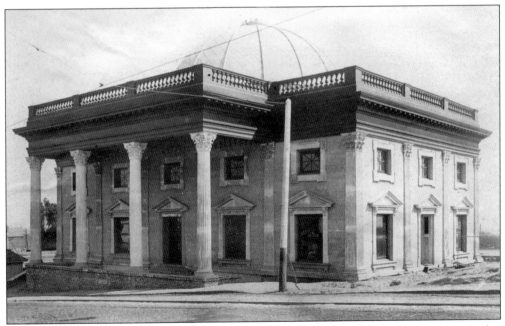

A 1907 view shows the City of San Pedro's new city hall building still under construction (no steps from the right side of the porch or from the door). The brick facade of the porch still needs to be stucco-coated, and there is a shovel leaning against the power pole along with other construction debris on the side of the building. Eventually the $52,000 facility opened for public inspection on January 1908, and the city government moved in on July 1, 1908.

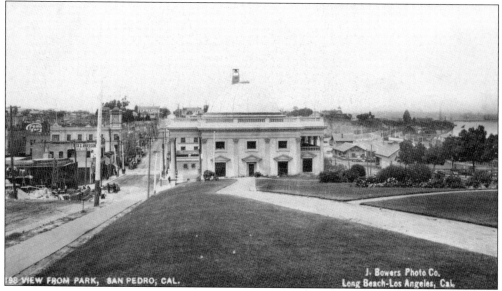

Looking north from the lawn of Plaza Park in 1909, the completed domed city hall building stands, with a price tag of $52,000. The architect was F. S. Allen, and the contractor was J. H. Roche. Across the street to the left of city hall is the then-new A. P. Ferl Building still under construction. (J. Bowers Photo Company.)

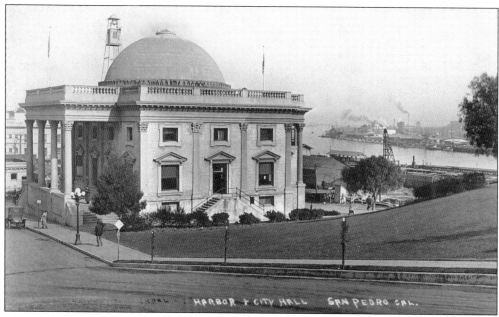

This c. 1920s photograph shows another view of the city hall building in which a new staircase was added to the side of the building because the slope of Plaza Park had been changed. Behind the dome of city hall is an 84-foot steel fire bell tower. The tower was built in October 1908 at a cost of $840. This building also contained the city's fire department and jail. The photograph shows how Seventh Street did not yet connect from Beacon Street to Harbor Boulevard.

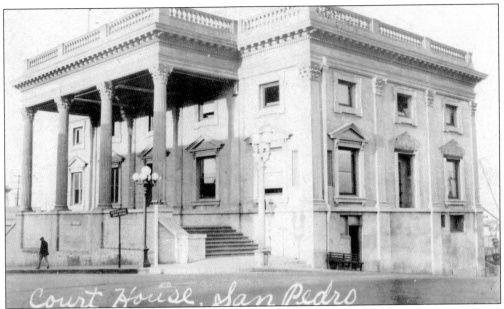

In this 1927 view of city hall, the stairway on the right side of the building and the domed roof have already been removed as part of the building's demolition. Seventh Street also now connects Beacon Street to Harbor Boulevard. This building will be replaced by the new seven-story municipal building.

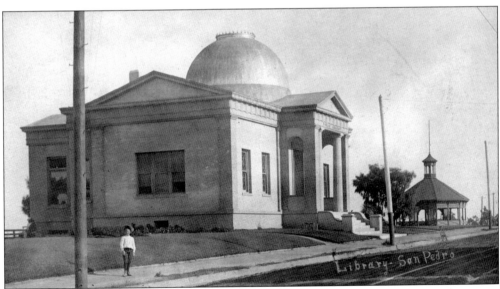

This postcard was mailed May 7, 1908, and shows the Carnegie Library that opened in 1906 located near Eighth and Beacon Streets. It was actually in Plaza Park, next to the wooden pavilion that was moved south a few hundred feet to make room for the library. A boy wearing a white shirt, knickers, and a straw hat poses for this picture standing on the sidewalk next to the dirt street.

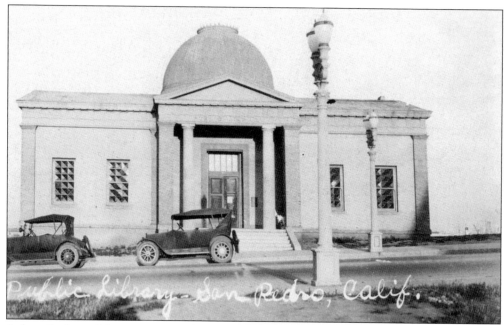

A frontal view of the entrance to the Carnegie Library is seen in this *c.* 1918 photograph on Beacon Street, which has finally been paved and had street lighting installed. Given a grant of $10,000 from Carnegie funds, this classical Revival–style building was designed by architects Edelsvard and Saffellas, along with H. V. Bradbeer. It operated as a library from 1906 to 1923 when it outgrew this facility. In 1966, the building was demolished.

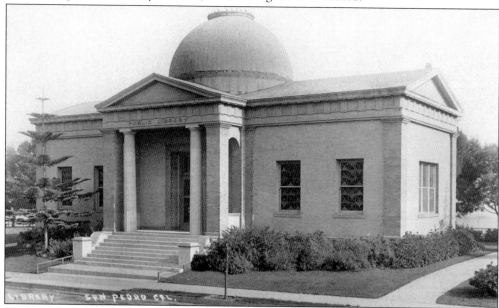

In this *c.* 1925 view of the Carnegie Library, the building houses the offices of the chamber of commerce, and in later years, it would hold the Seamen's Library. In 1922, the grade of the road (Beacon Street) was changed and reduced by 14 feet, and the building was gently lowered. This library building, with its two columns, is often confused with the city hall building that had four columns.

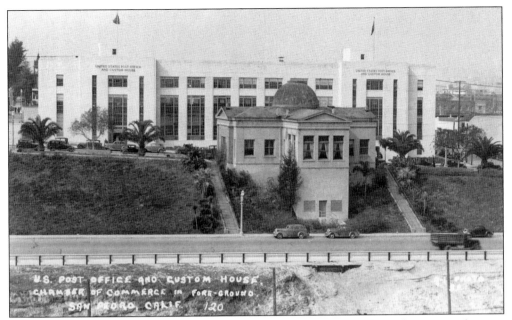

Looking across and over Harbor Boulevard, the Carnegie Library from the rear can be seen as well as the challenge of how early San Pedro had to deal with a building on cliffs. Behind the library are the then-new San Pedro Post Office and U.S. Customs Office, built in 1936. (A-1 Photo S.P.)

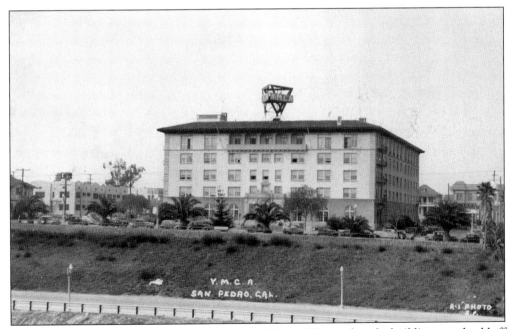

Constructed in 1926, this five-story Spanish Colonial Revival–style building on the bluff overlooking the harbor's main channel was known as the Army-Navy YMCA in this late 1930s view. The facility had 300 dormitory rooms, a running track, a gymnasium, a pool, a banquet room, and boxing and wrestling rooms. (A-1 Photo S.P.)

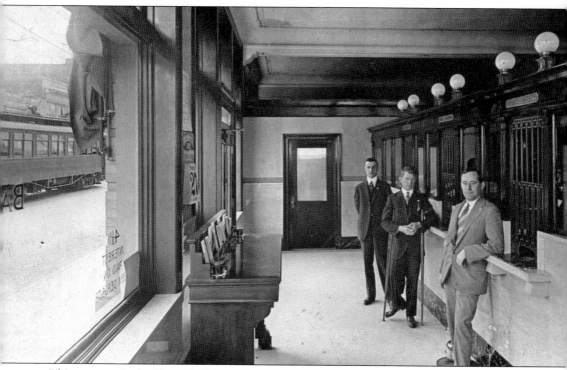

This panoramic double-wide folding postcard is a rare and unique look of the inside of the old Bank of San Pedro. One of the electric streetcars that ran on Sixth Street can be seen through

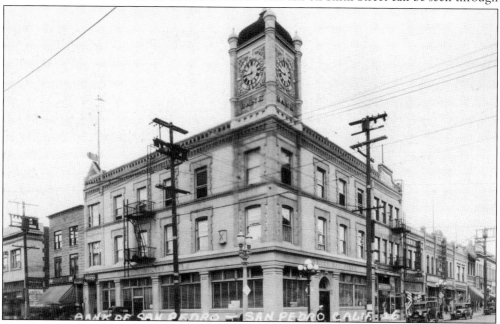

The Bank of San Pedro, with its ornate clock tower as seen here in 1927 on the corner of Sixth and Beacon Streets, was in the heart of the old business district. George Huntington Peck and William Kerckhoff established the bank in 1888. The bank's clock tower had to be removed when the 1933 Long Beach earthquake damaged it.

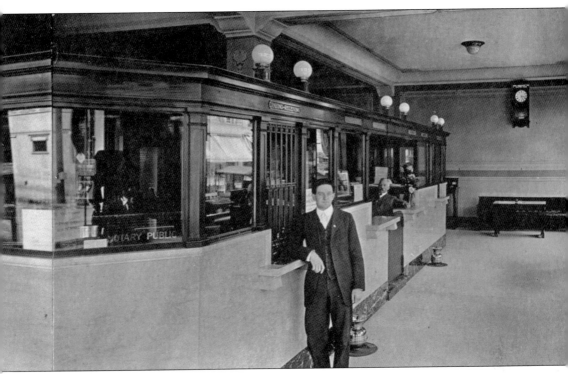

the bank window on the left.

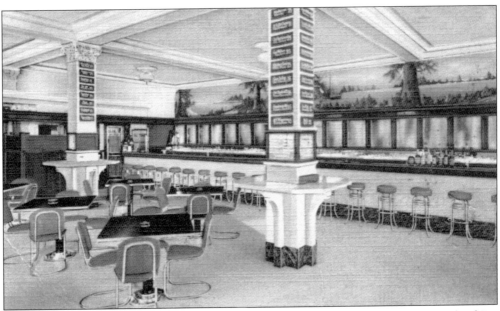

In this 1930s postcard, the interior of the Bank Café of San Pedro, previously the Bank of San Pedro, can be seen. The message on the back states, "The most unique café in the world changed from a bank to a café, equipped with latest modernistic furniture, Manager Anton Sumich."

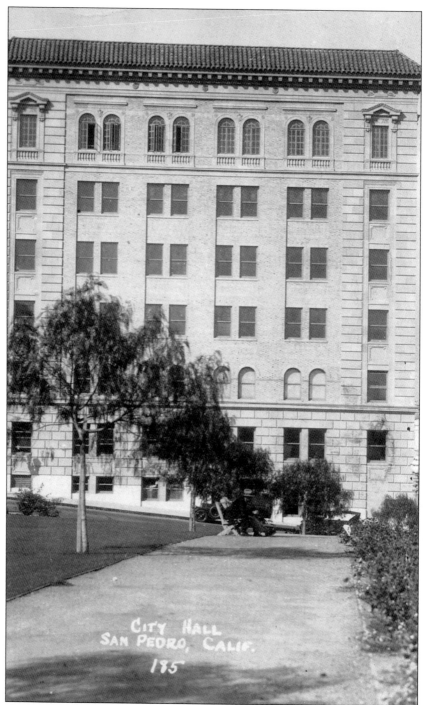

CITY HALL
SAN PEDRO, CALIF.
185

The brand-new municipal building was dedicated in 1928 and built on the site of the old San Pedro City Hall, located north of Seventh Street between Beacon Street and Harbor Boulevard. This seven-story structure held a police station, jail, courts, a fire department, and other city offices. It is still used as a municipal building today for the City of Los Angeles's 15th District offices.

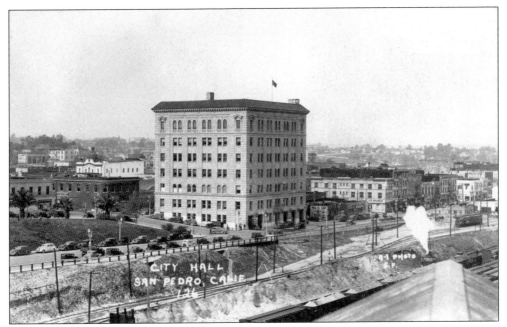

Known as the San Pedro City Hall, the municipal building was completed in the fall of 1928. This 112-foot-high, seven-story Beaux-Arts edifice has both neoclassical and baroque characteristics. The sixth floor has a beautiful wood-paneled courtroom, and the seventh floor housed the jail that was nicknamed "Seventh Heaven."

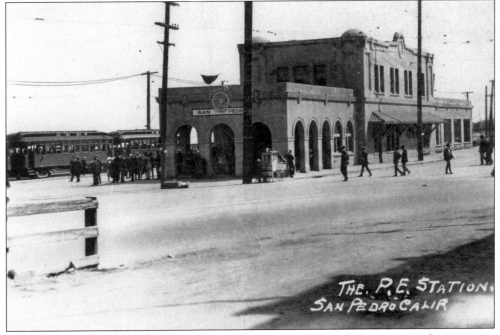

A peanut vendor, sitting with his pushcart next to the Pacific Electric Depot, waits for customers who might want a snack to take with them as the ride on the streetcar. The depot's location was conveniently placed next to the ferry and navy landing on the waterfront. The Red Car service was discontinued in 1958, and the building was demolished in 1961.

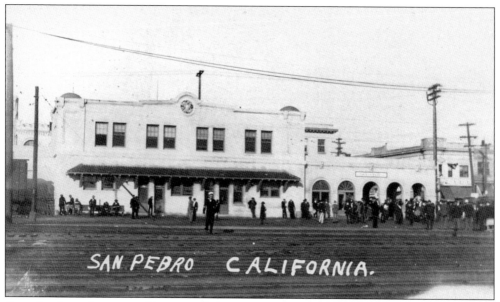

Crowds of people are standing around the new two-story Pacific Electric Depot waiting for the Red Line streetcars to arrive. This new depot was built in 1920 on the previous site of the old Southern Pacific Railroad Depot as part of the general regrading and alignment project of the San Pedro waterfront where high bluffs were cut down and an entirely new look was given to the business district.

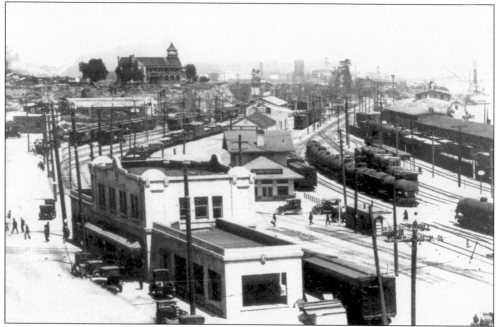

In this early 1920s view, there are considerable changes being made to the railroad track area running along the waterfront. In the foreground is the new Pacific Electric Building, just north of Fifth Street, and the new Southern Pacific Depot. In the distance, the former elegant Clarence Hotel (and one time San Pedro Hospital) is the last building still on top of Nob Hill before it was cut down to make way for the new Harbor Boulevard (part of the old Front Street).

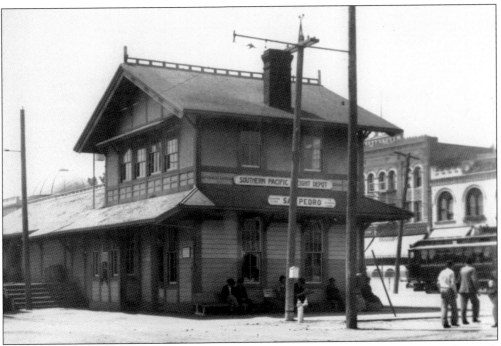

This is a 1906 view of the Southern Pacific Freight Depot that was built in 1903 on the south side of Fifth Street and east of Front Street. This wooden two-story depot was built in the railroad's typical Stick style, with a gable roof that was always perpendicular to the track. The dome of the city hall building can barely be seen to the left of the depot building.

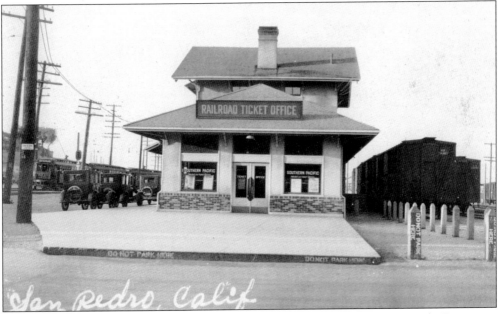

Looking north in 1920, this new Southern Pacific Railroad Passenger and Freight Depot was built north of Fifth Street and east of the newly named Harbor Boulevard (the old Front Street). The depot location was moved as part of track realignment and to create a clear area for the new Pacific Electric Depot.

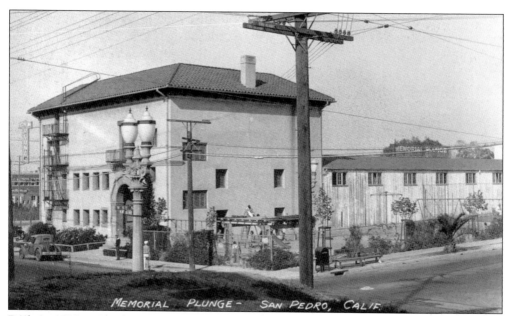

Built in 1925 at Ninth and Mesa Streets was this building dedicated to the memory of Mr. and Mrs. Anderson's two sons who died in the 1918 influenza epidemic. The building was placed on the National Register of Historic Places in 1985 and is now Anderson Memorial Recreation Center.

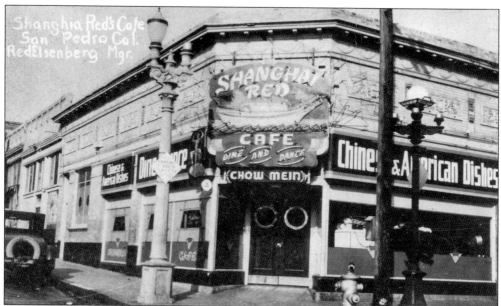

The world-famous Shanghai Red Café, owned and operated by Charles Eisenberg and located on the northwest corner of Fifth and Beacon Streets, is pictured here c. 1927. Beacon Street was known for bars, gambling houses, and "cathouses." Stories flourished of many a visiting sailor or worker from the docks who were entertained by ladies of the night, and some were "rolled" for their money after a night of heavy drinking. "Rolled" refers to the informal definition of after a night of drinking "to take money or belongings from somebody who cannot offer any resistance."

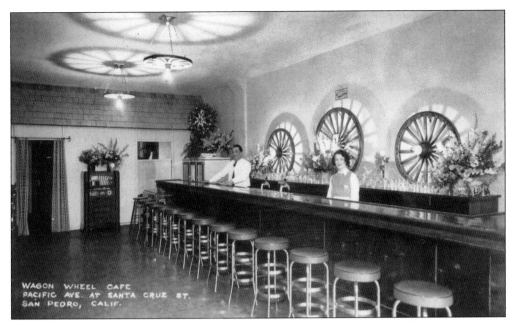

Here is a wonderful interior view from the 1930s of the Wagon Wheel Café that was at Pacific and Santa Cruz Streets. All the lighting fixtures are made of wagon wheels, and a flower arrangement on top of the refrigerator is also shaped like a wagon wheel.

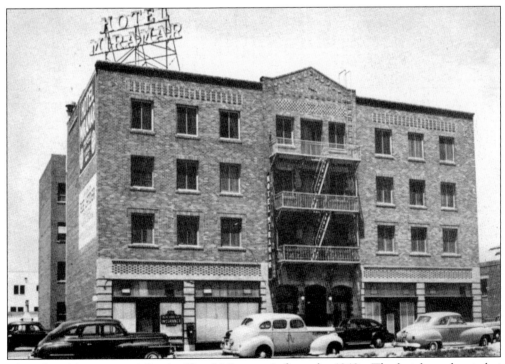

This advertising postcard for the Hotel Miramar is from the 1940s. The hotel was located at 431 Centre Street and boasted that it had 124 beautiful rooms and apartments, the "Newest in San Pedro." Today it is the location for the homes of the federal housing projects.

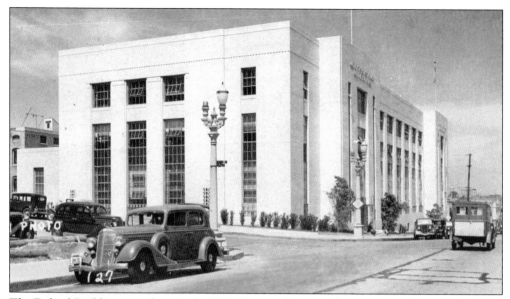

The Federal Building, seen here in the 1910s, houses the United States Post Office and Customs House and is located on Beacon Street between Eighth and Ninth Streets. Original to this building's lobby is a large mural by Flether Martin depicting the harbor area's heritage. The walls were surfaced with fine marble from Pennsylvania that contained many sea fossils. The building was placed on the National Register of Historic Places in 1985. It still serves as the main post office in San Pedro.

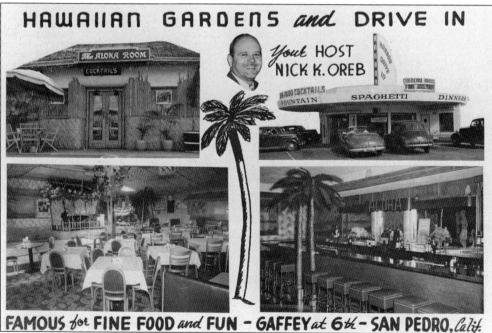

The Hawaiian Gardens and Drive-In (Nick Oreb's), located on the corner of Sixth and Gaffey Streets, was the first drive-in restaurant in San Pedro in the mid-1940s. It became a popular attraction and convenient for all age groups in San Pedro as well as the rest of the country. Later The Fireside and Don's Drive-In replaced it, and today Jack in the Box is at that corner location.

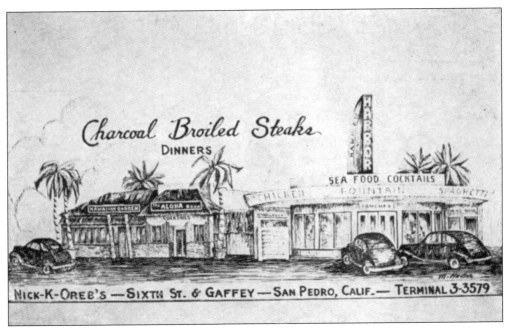

This advertising postcard is for Nick K. Oreb's Hawaiian Gardens and Drive-In, where a waitress would serve food right up to the car or a person could go inside to sit down and be waited on.

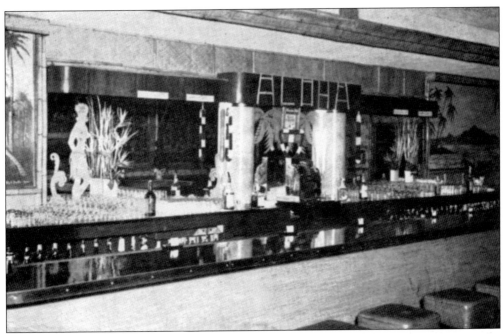

This is a wonderful interior view of the Aloha Room bar ornately decorated in a Hawaiian style. The bar was owned and operated by Nick K. Oreb and was part of the complex that also housed the drive-in.

The Pacific Electric Depot is seen here in 1941 with Harbor Boulevard on the left and Fifth Street on the north side of the building. The track area between First and Fifth Streets was the Pacific Electric's storage area for up to 75 cars that were not in use or in need of minor repair.

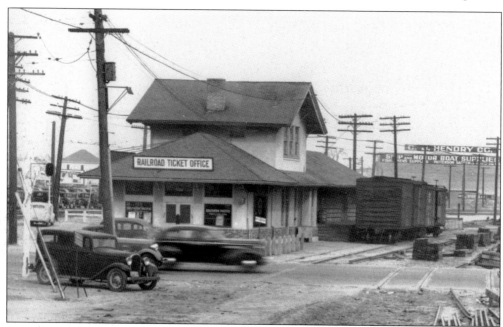

A car is traveling east on Fifth Street, which is still the only access across the tracks to the waterfront in the 1940s. The Southern Pacific Railroad built a second depot north of Fifth Street with brick and stucco exterior in the same architecture style to replace the old wooden depot that was south of Fifth Street.

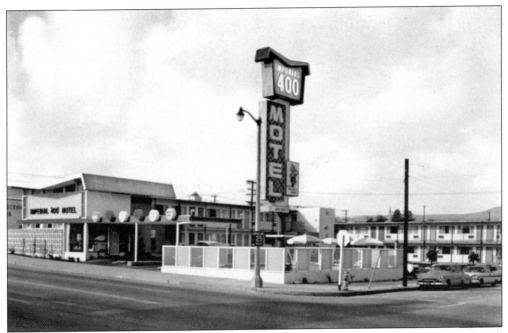

Imperial 400 Motel at 411 South Pacific Avenue is the subject of this advertising photograph postcard. The ad on the back states, "America's Fastest Growing Partnership Chain. All new heated swimming pool. Room TV, phones, free coffee, air-conditioned rooms."

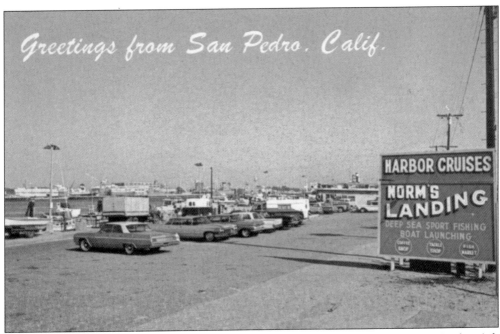

This 1960s view shows Norm's Landing with the Fisherman's Wharf Restaurant in the pink building at Berth 79. This center for deep-sea sportfishing has become a world-famous Southern California landmark. Today this area is part of Ports o' Call Village.

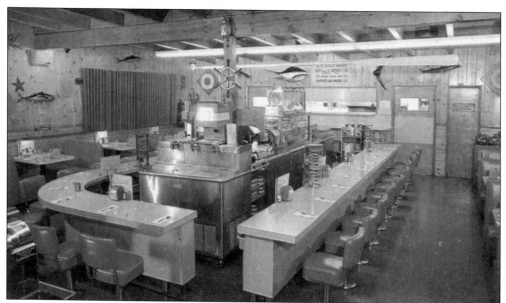

At Norm's Landing was the Fisherman's Wharf Restaurant, located at Berth 79. Here is an interior photograph of the restaurant. The card advertises, "This modern and efficient 24 hour restaurant serves hundreds of meals daily in a nautical atmosphere highlighted by prompt courteous service. The menu features local seafood specialties such as, lobster, abalone and sea bass and a wide variety of other dishes." It had great clam chowder.

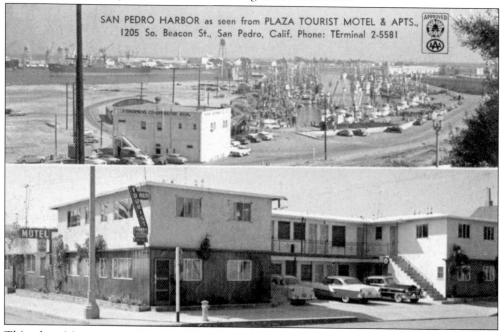

This advertising postcard from the Plaza Tourist Motel is from the late 1950s and has two views within one card. The top is a scene from the motel looking at Fishman's Slip with all the tuna boats, while the lower image is of the motel itself. It claims the following in its advertisement: "Its many tourist attractions include the Palos Verdes Hills, the scenic drive along the Palisades, picturesque Catalina Island, the Wayfarer's Chapel and Marineland." (Elmo M. Sellers.)

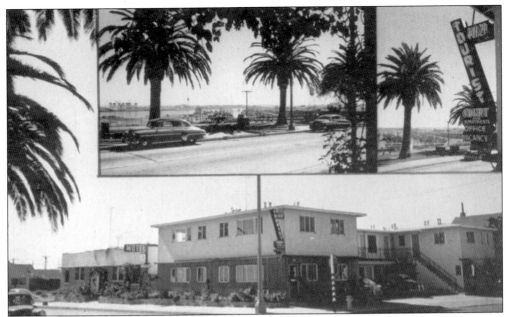

This is another 1950s view of the Plaza Tourist Motel and Furnished Apartments. Located at 1205 North Beacon Street, it advertises, "Overlooking the world's greatest fishing port and largest man-made harbor is famous for its scenic beauty and healthful climate. It has two picturesque beaches. The one inside the breakwater offering safe swimming for the young, while the surf bathers can enjoy the stimulating Pacific surf, which rolls in east of Point Fermin." (Mellinger Studio.)

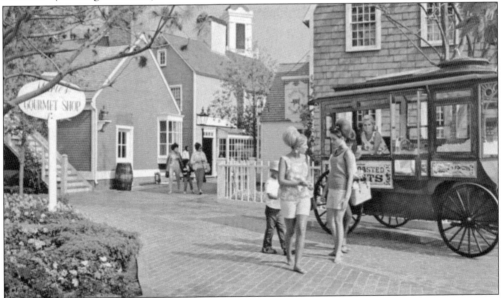

In the 1960s, Ports o' Call Village was built to provide tourists and the local community a place along the harbor to shop and dine while enjoying the views. Mailed in 1969, this photograph card shows young women in their 1960s–style coiffures enjoying popcorn from the snack cart at Ports o' Call Village. The ad reads, "A replica of an early American village bathed in the sunshine of California." (Photograph by Jay Jossman.)

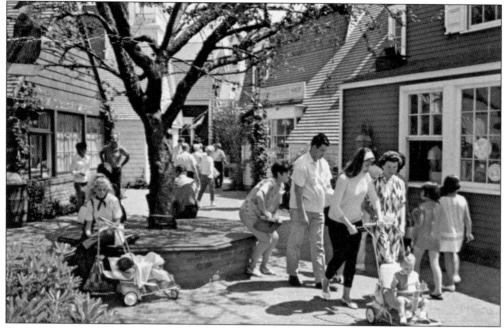

In this photograph postcard, mailed in 1970, families are enjoying their way through the shops at Ports o' Call Village. The ad on the reverse states, "Quaint shops and restaurants in the colonial style with a California background." (Photograph by Jay Jossman.)

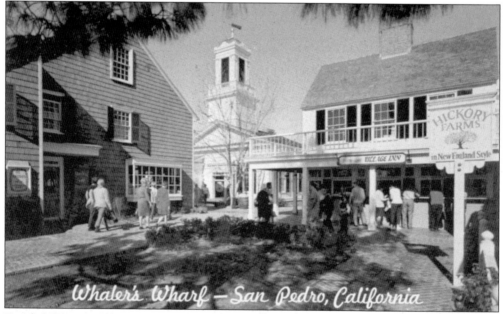

Entitled "Town Hall Square at Whaler's Wharf, San Pedro, California," this photograph shows visitors strolling among the many shops at Ports o' Call Village. Besides mentioning its Cape Cod–like style in architecture, it states its location as "the west side of the main Channel at the Port of Los Angeles at the south end of the Ports o' Call area." Whaler's Wharf Village was a second phase of Ports o' Call–like shops along the edge of the harbor. (Photograph by George E. Watson.)

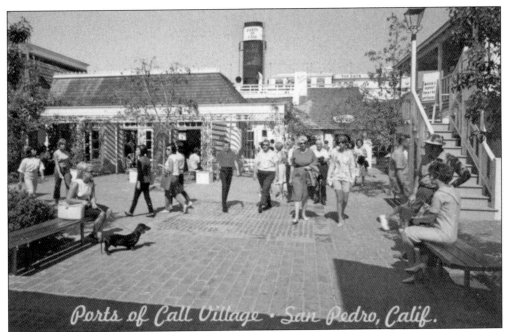

Ports o' Call Village in San Pedro, California, is once again the subject and title of this photograph postcard. It shows a scene of the main part of the village, with the stack of the *Sierra Nevada*, an old paddle-wheel ferry from northern California, in the background above the buildings. Permanently docked, the boat had a variety of little shops and an arcade. Residents and visitors alike enjoyed shopping and just strolling among the many shops of this recreated seaside village.

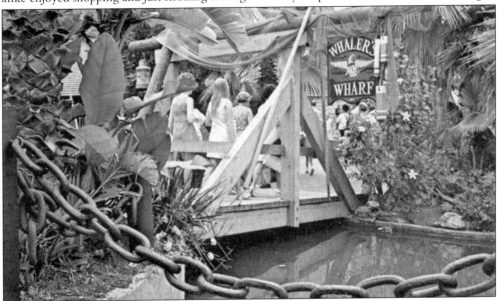

People are seen crossing a bridge that was the entrance to the Ports o' Call Restaurant and Whaler's Wharf Village. The Whaler's Wharf was located at the south end of Ports o' Call Village with a restaurant at its furthest point. It was added several years after the first part of Ports o' Call Village opened. The village was architecturally styled in the 19th-century Massachusetts fishing village tradition.

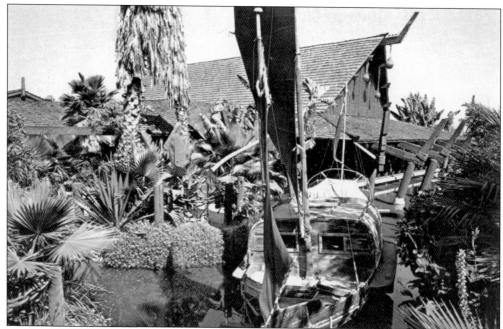

This photograph postcard demonstrates the elaborate entrance into the Ports o' Call Restaurant in the 1960s, with its lagoon and sampan. The back of the card advertises, "This atmospheric restaurant located in Ports o' Call Village at Berth 76, Port of Los Angeles, affords diners an excellent view of great ships from many foreign lands as they pass within hailing distance along the Harbor's Main Channel." (Golden West.)

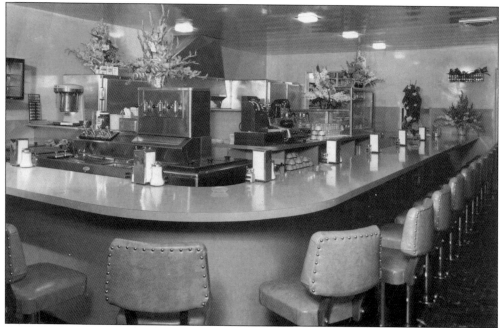

This is a classic example of what a 1950s lunch and dinner counter typically looked like. Here is an interior view of RYP's, located at 710 Weymouth Avenue. It was owned by the Rypdali family, who also owned the Hamburger Hut on Gaffey Street.

Three

RESIDENTIAL AREAS

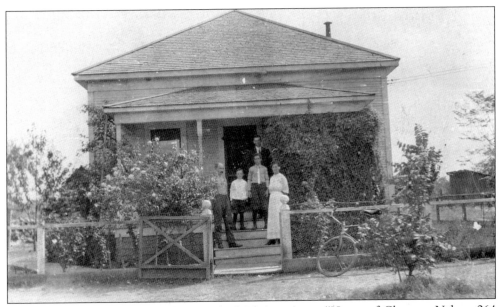

This postcard was not mailed, but on the back is written, "Home of Clarence Nelson 264 Second Street San Pedro Jan. 19, 1913." It appears as if the members of the family are posing on the front steps of their home with a bicycle leaning against the front fence. The house was situated in the Nob Hill section of San Pedro, a middle-to-high income area in 1913. Today this house is the location of the homes of the federal housing projects.

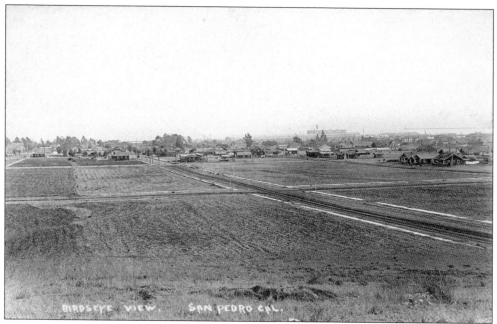

This *c.* 1918 view was taken from around Seventeenth Street and Cabrillo Avenue looking southeast with acres of undeveloped land seen in the immediate foreground under cultivation or being farmed. Now there are either houses or businesses taking up this space. Barely visible on the horizon and to the right of center is the historic Warehouse No. One and the lighthouse at the end of the breakwater.

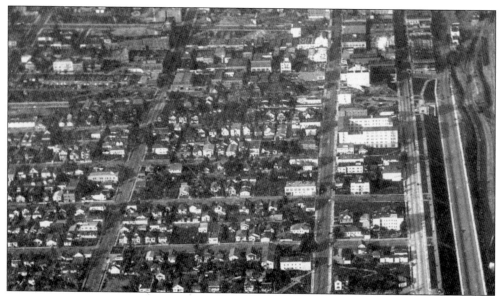

Located on the right side of this photograph is a long strip of land between Harbor Boulevard and Beacon Street called Plaza Park, with the Carnegie Library near the north end of it. Above the park is the steel framework of the new municipal building still under construction. This 1927 aerial view is from Thirteenth Street, in the lower foreground, looking north to Third Street in the upper portion. Centre Street is on the left and Harbor Boulevard on the right.

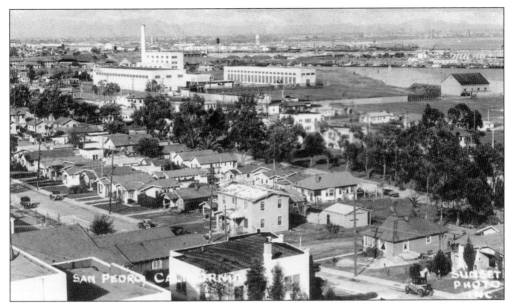

In this 1925 view from just above Kerckoff Avenue and Thirty-fourth Street, one can see the smokestack and building of the old Trona plant on the grounds of Fort MacArthur. In the top center of the photograph is the fence with the navy's Trona Field printed on it next to Fort MacArthur. West of Fort MacArthur, along Pacific Avenue (foreground), is the area called Whiskey Flats. Most of the homes in this area are still there today, with a few additions. (Sunset Photo Inc.)

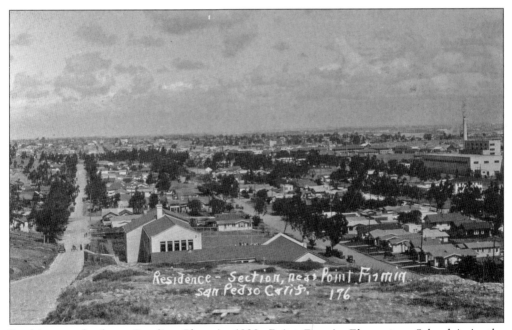

Looking north along Carolina Place in 1930, Point Fermin Elementary School is in the foreground at the bottom of the hill. The textured-concrete road surface of Carolina Place is the same today as when it was first originally installed.

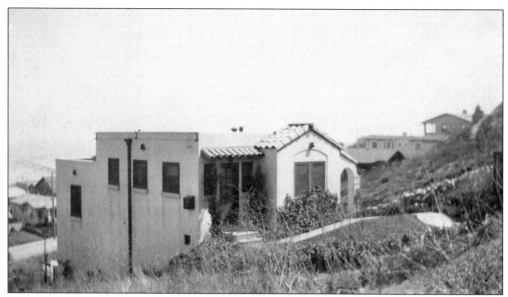

A 1927 view, looking southeast from about Peck Avenue, shows a charming stucco, Spanish-style house on the hillside. The breakwater is barely visible just behind the house on the left of photograph.

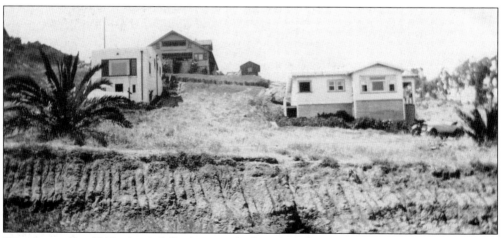

Here is another 1927 view of the same Spanish-style home of the previous photograph but looking west from Carolina Place up the hillside. Only a few homes occupy the sparsely populated hillside, with no concern for garages. However, today, it is densely populated with houses, apartments, and condominiums, and parking is a problem.

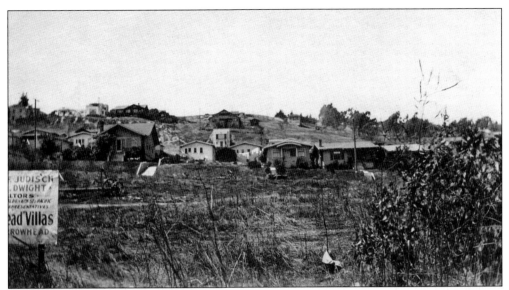

Looking west in 1927 from about Pacific Avenue near Thirty-second Street, there were only a few houses on the hillside of the Point Fermin school area. Behind the real estate advertising billboard in the left foreground sits an old horse-drawn wagon abandoned in the open field.

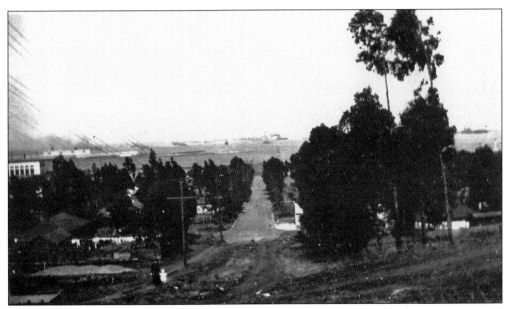

A 1927 photograph postcard captures lots of mature trees and two people in the foreground walking down the dirt road, east on Thirty-second Street, from Gaffey Street to Peck Avenue.

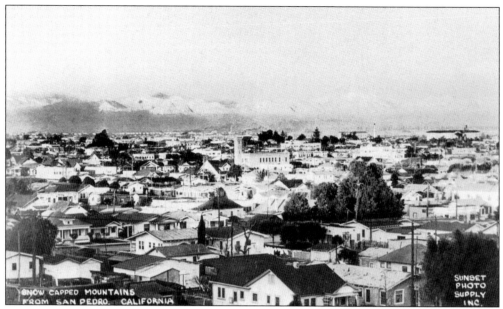

This photograph postcard shows a beautiful, clear day in the 1930s looking north from about Nineteenth and Meyler Streets in the Alma Park area. This is a great overall scene of San Pedro, with the snow-covered San Gabriel Mountains in the background. (Sunset Photo Supply Inc.)

These three charming little cottages look the same today as they did back in the 1930s when this photograph was taken; the only difference is that the palm trees are taller. The cottages are located on the east side of Pacific Avenue starting at Thirty-eight Street looking north. (Theo Sohmer.)

Looking north up Patton Avenue from where Nineteenth Street crosses it, this residential neighborhood in the 1930s still had several undeveloped parcels of land. The first two houses on the left side of the street are still there today but have had some changes made to them. There are also no empty lots in the area unless a house is torn down for remodeling.

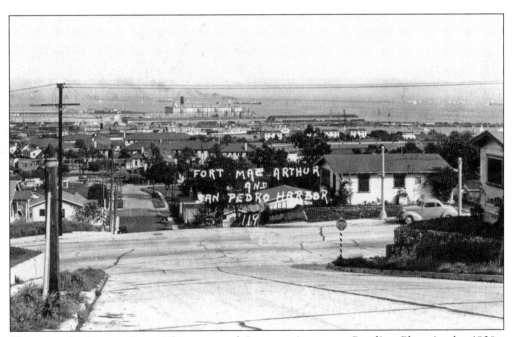

This view looks east down Thirty-second Street as it crosses Carolina Place in the 1930s, before continuing onto the grounds of Fort MacArthur. Several of the navy's destroyers are tied up at the docks, and battleships are anchored in the outer harbor.

From the rising hills of San Pedro, looking east from the intersection of Twentieth Street and Patton Avenue, the next block east (down the hill) is Walker Avenue. In this 1940s photograph, there is an IGA market at that location on Twentieth Street and Walker Avenue. Today it is the last remaining McCowan's Market in town. This postcard was mailed December 26, 1945, with the message, "This is the place I am in now. I don't know for how long about 2 or 3 weeks. I believe I will let you all know when I leave."

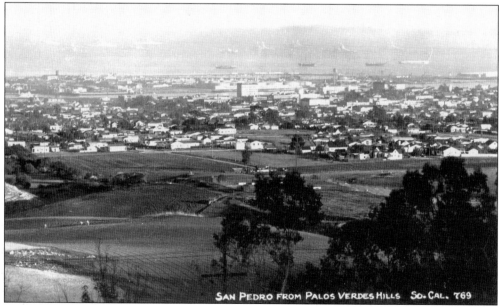

In this *c.* 1939 view from the Palos Verdes Hill area, the seven-story city hall building is the tallest structure in San Pedro and is in the center of this view. In the foreground is a lot of land still being used for farming and livestock grazing around town. Also, in the distance, anchored in the outer harbor, are several of the navy's battleships.

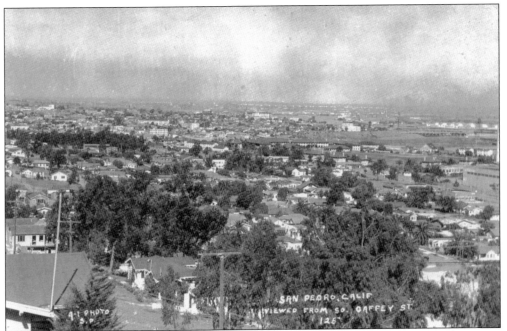

This is 1940s photograph looks north from the observation lookout up on Gaffey Street near Thirty-fifth Street. This is a great overview of San Pedro that includes housing, Fort MacArthur, the harbor, the channel, and part of Terminal Island in the distance.

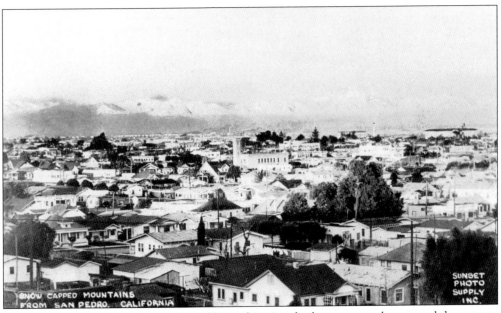

Taken from the top of the YMCA building, this view looks west over houses and downtown businesses toward the nearly barren hillside of Palos Verdes. There are only a few houses visible in the Miraleste area. The large, older homes of historic Vinegar Hill are clearly seen in the foreground. This postcard was mailed September 6, 1944, with a short message, "Mariam was 6 years old on the 2nd of Sept. Had her tonsils out a few days ago is getting along OK."

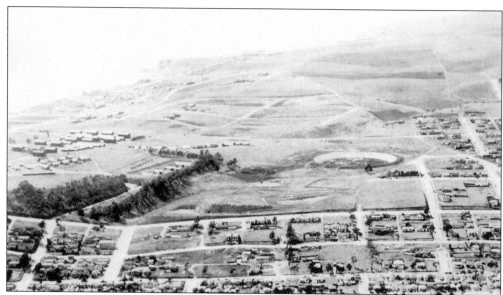

Past the Upper Reservation of Fort MacArthur's group of buildings, on the left center edge of this photograph bordered by tress, is the open countryside of San Pedro and Palos Verdes in 1934. Gaffey Street runs across the center of the photograph above the houses in the foreground. Fort MacArthur's land extends to the right, including the round ring, which was the fuel storage for the military. The tip of Twenty-fifth Street that ends at Western Avenue is near the right corner of the photograph. Also in the bottom right corner is a very small portion of Kerckhoff Street, visible in this 1934 image. (Western Airfotos Inc.)

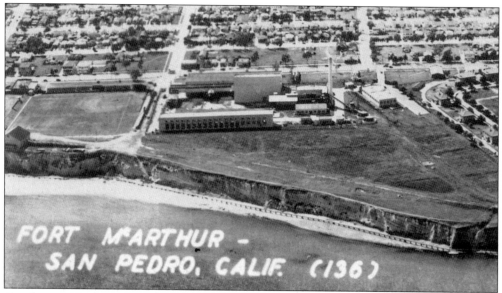

Another 1934 aerial view of the Middle Reservation of Fort MacArthur shows how the fort is situated right on the edge of the bluffs overlooking the harbor. Trona Field is on the left and in the center is the old historic Trona plant building and smokestack. The American Trona processing plant (potash) was placed on the National Register of Historic Places in 1982. (Western Airfotos Inc.)

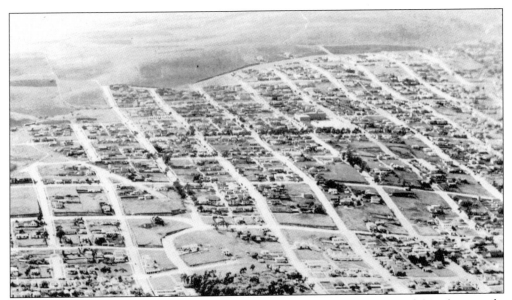

Note in this 1934 view that there is no housing across the upper portion of this photograph, which is Western Avenue—all that exists are open fields. On the left side of this view is a short portion of Twenty-seventh Street, with Gaffey Street running across the lower third of the foreground. Gaffey Street jogs at Twenty-fifth Street, which can be seen even today. In the far lower right corner is Grand Avenue. The large L-shaped building to the right of the center of this photograph is Leland Street Elementary School. (Western Airfotos Inc.)

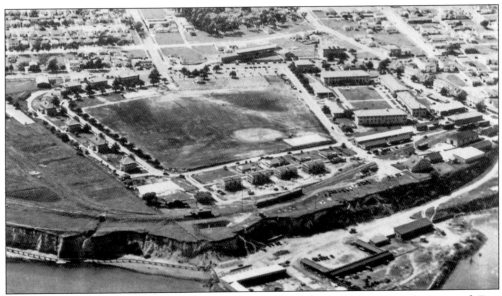

A close-up aerial shows the large parade grounds and smaller quadrangle areas of Fort MacArthur's Middle Reservation near the harbor in this 1934 image. This area of the fort contains the original 500 *varas* square (1846) and was placed on the National Register of Historic Places in 1982. (Western Airfotos Inc.)

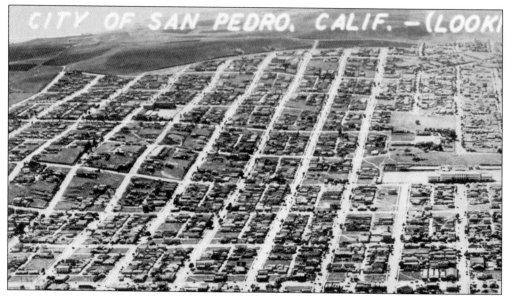

In 1934, as evidenced by this photograph, there are still several vacant, undeveloped lots in town and almost nothing but open field above Western Avenue at the top. The town also stopped at Twenty-fifth Street on the left edge. At Fourteenth Street on the right and Pacific Avenue in the lower foreground, the area is considerably more populated and developed. (Western Airfotos Inc.)

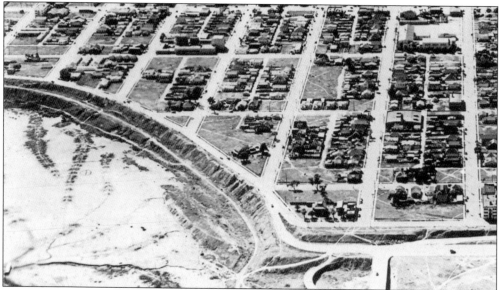

Another close-up aerial shows the curved street of Crescent Avenue in 1934. This area, at the time, was part of the harbor's undeveloped mud flats. The photograph encompasses Twentieth Street on the left to Fifteenth Street on the right and Pacific Avenue at the top to Beacon Street (then Harbor Boulevard) in the lower right corner. The closer to the water a person got, the fewer houses and more undeveloped parcels of land there were. (Western Airfotos Inc.)

74

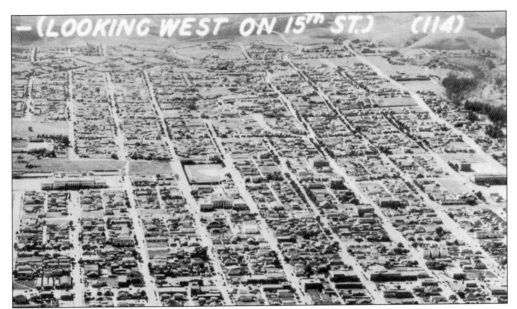

This 1934 aerial shows the New Dana Junior High School in the center left between Sixteenth and Fourteenth Streets on Cabrillo Avenue. To the right, a few blocks away and surrounded by dark fences, is Daniel's Field. In front of the field is the old high school building on Gaffey Street that was demolished in 1936. On the right center edge of the photograph is Cabrillo Avenue Elementary School, which is still on Seventh Street and Cabrillo Avenue. The emptiness just above the school would soon become the site of Mary Star of the Sea's new parish. The dark area near the right upper corner is Gaffey Canyon with its trees and undeveloped land. (Western Airfotos Inc.)

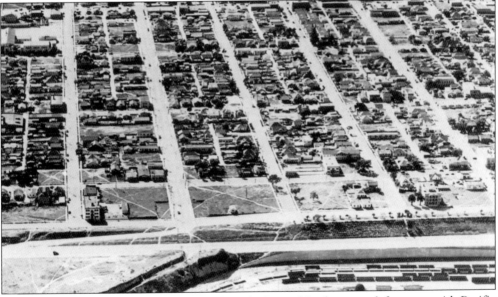

In this 1934 view, Fifteenth Street School can be located in the upper left corner with Pacific Avenue running across the top. Located in the lower right corner, just above Harbor Boulevard on Beacon Street, are Tenth Street and the c. 1900 Victoria Apartments, which still claims to be the oldest apartment building in town. (Western Airfotos Inc.)

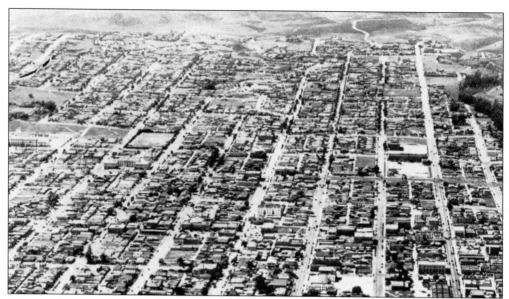

The new Dana Junior High School can be seen on the left edge of this 1934 aerial of the town from the east. Construction of the new San Pedro High School, located on the empty lot behind Dana, has yet to be started. The condemned building of the old San Pedro High School, demolished in 1936, can be seen a few blocks to the right of Dana. Behind the old high school is the square empty space of Daniel's Field. This view covers the area from Centre Street at the lower foreground past Western Avenue at the top of the photograph. Also seen is part of Seventeenth Street on the left all the way north to Sixth Street on the right. (Western Airfotos Inc.)

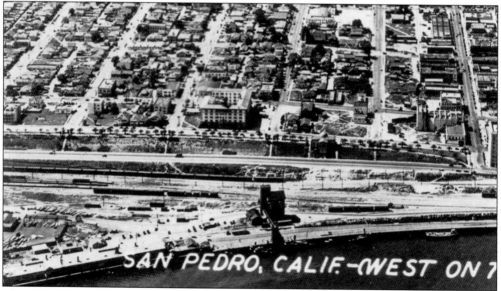

The Globe A-1 grain elevator tower is located on the waterfront (lower foreground) with the YMCA building just above it in this 1934 aerial of San Pedro. The small domed building a block to the right is the Carnegie Library, with the empty lot above being the future site of a new post office. This view covers the area from the waterfront in the lower foreground to just past Centre Street on the top and from Twelfth Street on the left to just pasted Seventh Street on the right. (Western Airfotos Inc.)

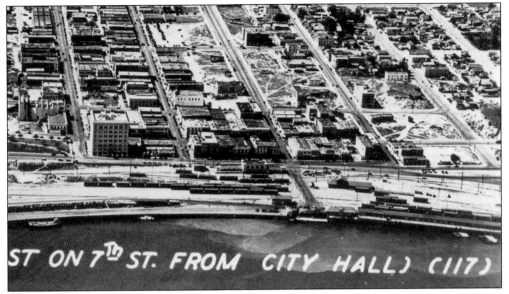

ST ON 7ᵗʰ ST. FROM CITY HALL) (117)

In this 1934 image of the waterfront and business district, the seven-story municipal building is the tallest building in town. To the left of the municipal building is the Fox Cabrillo Theater, and to the right is the infamous Beacon Street red-light district. This view covers from the waterfront at the lower foreground almost to Mesa Street at the top and just short of Eighth Street on the left to Second Street on the right. (Western Airfotos Inc.)

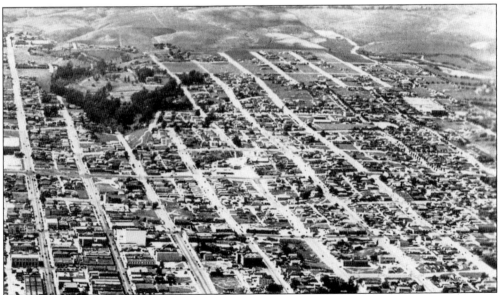

In 1934, the city was just beginning to expand up to and touch the open hillside around Western Avenue at the top of this view. On the left edge of the photograph is Seventh Street, and on the right is Summerland Street, with the Peck Park area beyond it. On the bottom edge, part of Mesa Street and below can be seen. The large dark area with the cluster of trees is the John T. Gaffey Estate, with his historic La Rambla Hacienda surrounded by trees. Now the area has residences in the canyon, and the YMCA moved in during the 1960s. (Western Airfotos Inc.)

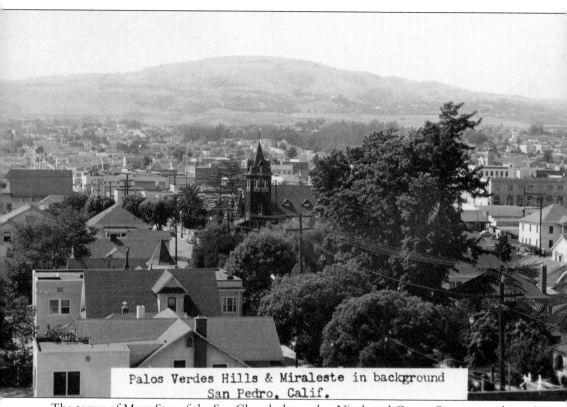

Palos Verdes Hills & Miraleste in background
San Pedro, Calif.

The tower of Mary Star of the Sea Church, located at Ninth and Centre Streets, stands out in the center of the photograph above the houses and trees of the area in the 1940s. Looking west, the Palos Verdes' hill, in the background, is still open country with only a few small groups of housing dotting the Miraleste area.

Four

SCHOOLS, CHURCHES, AND THEATERS

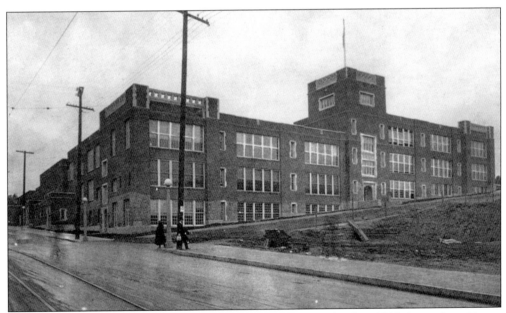

The first public school built in San Pedro was Fifth Street School in 1885, located on Centre Street between Fifth and Sixth Streets. In 1916, a brick structure replaced the old wooden school building, and in 1927, this building was demolished, and students transferred to the new Cabrillo Elementary School.

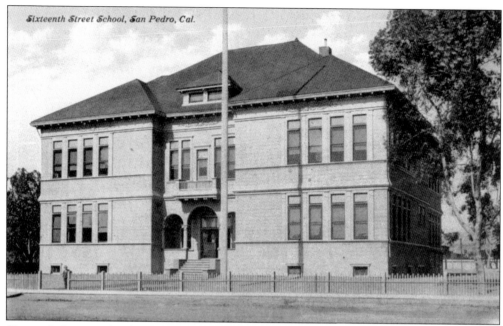

Sixteenth Street School, San Pedro, Cal.

Sixteenth Street School was the title given in this photograph, but the school changed to Fifteenth Street School in 1909 after San Pedro became part of the city of Los Angeles. Built in 1901, this wooden structure was completely destroyed by fire in 1922. When San Pedro High School was started in 1903, it used the second floor of this school for two years until a new high school was built on Gaffey Street.

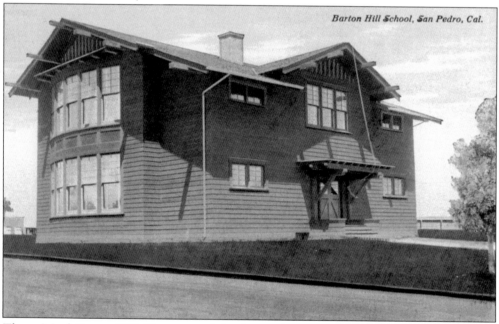

Barton Hill School, San Pedro, Cal.

The original Barton Hill Elementary School, seen here, opened for classes in 1906 for 60 children in this two-story wooden building that was used until 1922. The school was named after Albert G. Barton, a postmaster for the City of San Pedro. It is located on north Pacific Avenue and O'Farrell Street.

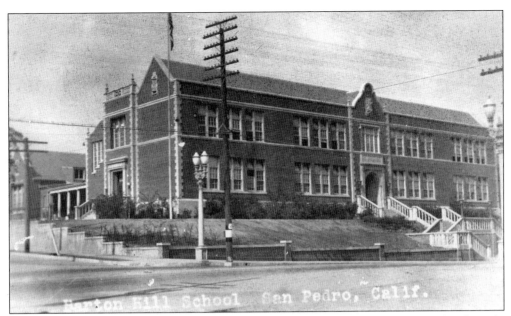

This 1920s view shows the new Barton Hill Elementary School's main building, handsomely constructed of brick with concrete trim. The school suffered only a little damage from the 1933 earthquake, but students were moved to tents and portable bungalows temporarily. During this period, protruding concrete trim was removed and the entire building was reinforced, covered with stucco, and modernized to conform to the new safety codes. It remains in use today.

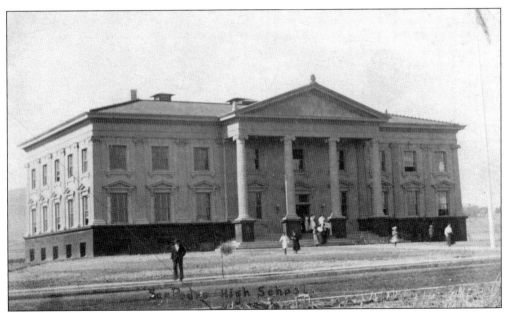

This 1906 view shows students in front of the new San Pedro High School building constructed on Gaffey Street. This impressive Greek Revival building did not hold classes until 1906, for when the school was first established in 1903, it met on the second floor of present-day Fifteenth Street School. From one of the school's new students, this postcard has a written message, "My room is in the first floor on the right hand side but toward back."

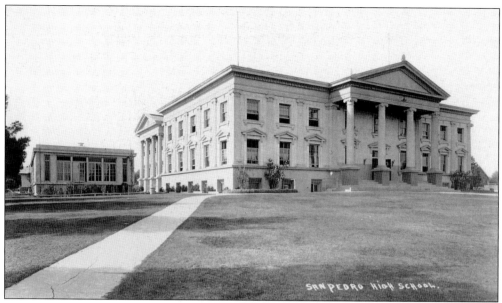

This is another image of San Pedro High School's campus, located on Gaffey Street between Twelfth and Thirteenth Streets. Its main building and campus grew to a mismatched collection of buildings over an area of seven acres by this time in 1930. The main two-story building with a full basement, after 27 years of operation, was severely damaged by the March 10, 1933, Long Beach earthquake. So damaged, it was deemed unsafe to occupy, and it was necessary for a new facility to be built.

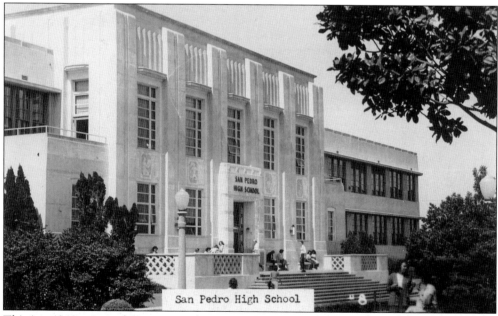

This is a 1940s view of the present-day San Pedro High School's main building, which faces east towards the harbor. This high school was constructed to replace the old high school damaged by the 1933 earthquake. The architect, George Kaufman, designed this building in a style known as Streamlined Moderne. The four plaques over the entrance depict the stylized realism, the academic, the sport, and the technical purposes of education.

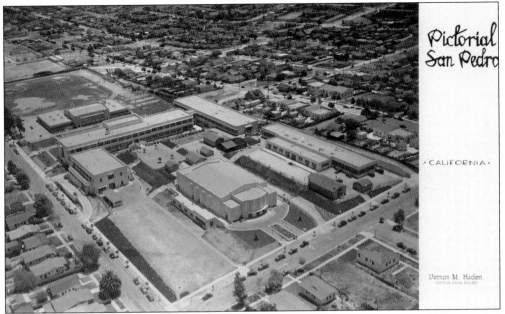

This is a fabulous 1940s aerial of the San Pedro High School original campus, which occupied only 18 acres but expanded eventually to cover over 35 acres. The large building in the center of the photograph is the auditorium with walkways leading to Leland Street. (Photograph by Vernon M. Haden.)

This is a great 1927 view of Point Fermin School perched on a hill overlooking San Pedro. It first opened in 1912 in portable bungalows on Kerckhoff Street near Thirty-second Street. This stucco-covered building, constructed in 1922, became the school's home to make room for the children coming from nearby Fort MacArthur.

This 1927 view looks south on Carolina Place from Thirty-second Street with Point Fermin Elementary School to the left of the street. The houses north of the school are still there today, but all the empty lots have had houses or apartment built on them.

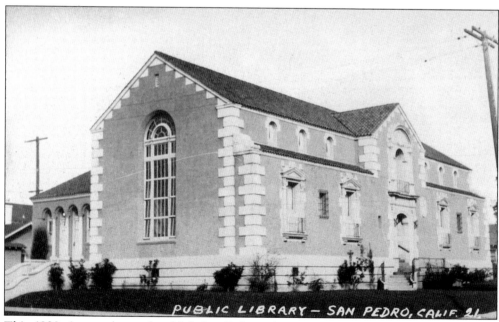

This 1920s image shows the third San Pedro Library that was located on Gaffey Street between Ninth and Tenth Streets. In 1983, the current library was built on the same site.

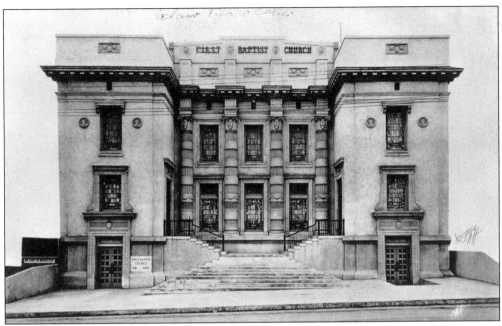

The First Baptist Church was constructed in 1919 at 555 West Seventh Street. The building features Egyptian columns and stained-glass windows designed by architect Norman Marsh in the Beaux-Arts classical style. The church is still at the same location today.

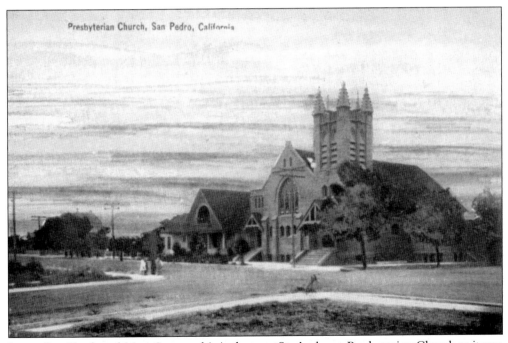

Located at Tenth and Mesa Streets, this is the new St. Andrews Presbyterian Church as it was dedicated in 1907. However, it soon dropped the saint from its name and was known simply as the First Presbyterian Church. The building still stands today, but the tower has been removed and other cosmetic changes have been made.

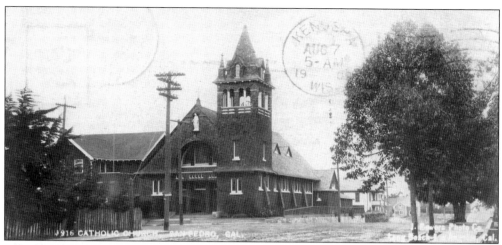

The date on this postcard can be quickly confirmed with the postal cancellation mark of August 7, 1909, stamped visibly on its front. This is the second site of Mary Star of the Sea Catholic Church, located on the northwest corner of Ninth and Centre Streets and dedicated in July 1905. Located first at 351 West Ninth Street in 1889, the site later became the Carpenter's Union Hall and Knights of Columbus Building. (J. Bowers Photo Company.)

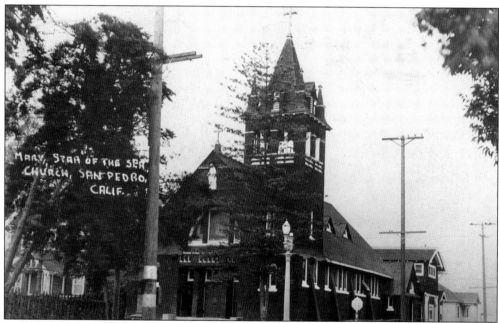

This postcard of Mary Star of the Sea Catholic Church was mailed on March 6, 1947, with the message, "Don't think that I have forgotten your birthday. Am mailing you St Augustine's Quest of Wisdom and think you will profit by reading. Was laid off 28th of Feb. So now I should get some much-needed rest. Say a few prayers for me & I hope you keep well. Love Ward." The Mary Star of the Sea parish built a church in 1958 at a new site located at Seventh and Meyler Streets. This church building was demolished, and an empty lot sat there for decades. It is now the site of new townhouses.

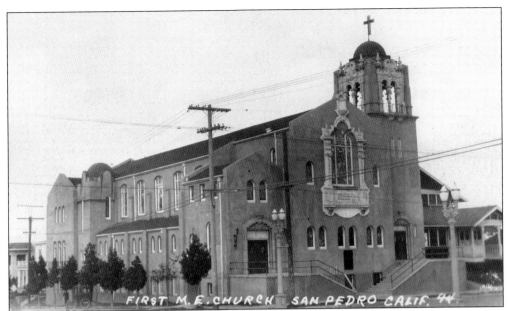

This building was completed in July 1923 for the First M. E. Church of San Pedro. Located at Sixth and Grand Streets, it had a rich Castilian facade with elaborately decorated front windows and an encrusted tower capped by a belfry and dome on which the lighted cross was mounted. Sailors entering the harbor at night could see the cross, thus carrying out the tradition that the church offered a message to those who traveled the deep seas. Presently the San Pedro United Methodist Church occupies the site.

This postcard of the First Christian Church of San Pedro at 1125 Gaffey Street was mailed on December 13, 1948, with the message, "Here today for church! This is our church at San Pedro down at the L.A. Harbor town. It is a nice church & we are interesting town the ocean is interesting." Today the building is a Sons of Norway Ulabrand Hall Lodge No. 24.

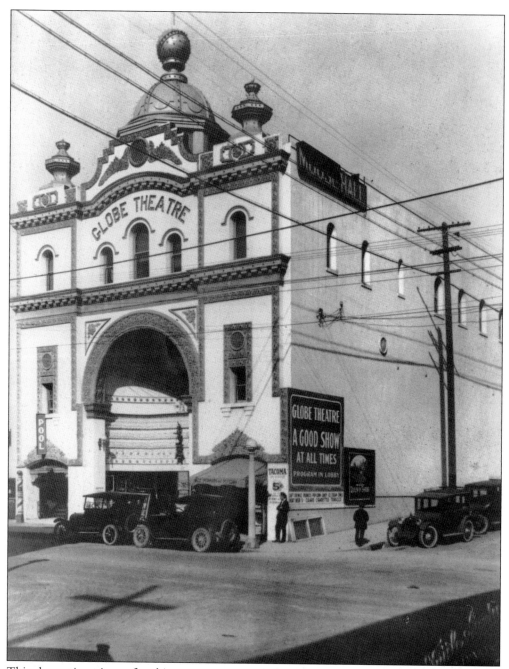

This decorative piece of architecture was captured in this 1928 photograph postcard of the Globe Theatre. It was located at Sixth and Palos Verdes Streets and was built in 1912. The theater was first used for old vaudeville performing acts before being revamped into a movie theater. The sign on the side of the theatre boasts, "Globe Theatre Good Shows At All Times Program in Lobby." The Globe was torn down in 1971 as part of the redevelopment of the old Beacon Street area.

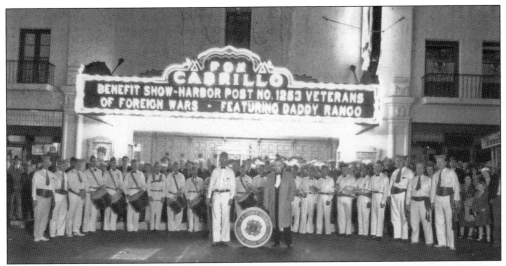

The Los Angeles Council Drum and Bugle Corps poses for a photograph in front of the Fox Cabrillo Theater at a special event in 1932, as seen on the marquee. The theater was located at 115 West Seventh Street and was built in 1923. The same architects of the Egyptian Theater in Hollywood, Gabriel Meyer and Phillip Holler, designed the Fox Cabrillo. The first movie, a silent film, premiered here in 1923. The "talkies" started showing in 1928, and it continued as a popular movie house until its demolition in 1958 when it was replaced by a parking lot.

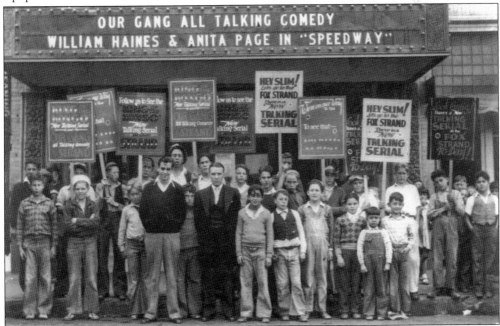

Our Gang shows up on the marquee in this photograph in front of the Fox Strand Theater on Pacific Avenue (the boys are holding signs for another movie, *King of the Kongo*). All of these shows were released in 1929 and features the newest advancement in films, talking sound. The Strand was a popular movie house for decades in San Pedro until space was needed for a parking lot of a bank.

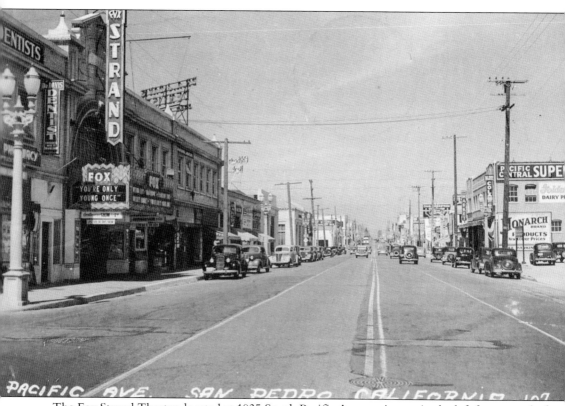

The Fox Strand Theater, located at 1035 South Pacific Avenue, is seen in the left foreground of this photograph. The marquee advertises the movie *You're Only Young Once*, which was released in 1938 and starred Mickey Rooney. The entire block where the theater was once located is now occupied by Washington Mutual Bank.

Five

"SUNKEN CITY," POINT FERMIN, AND PARKS

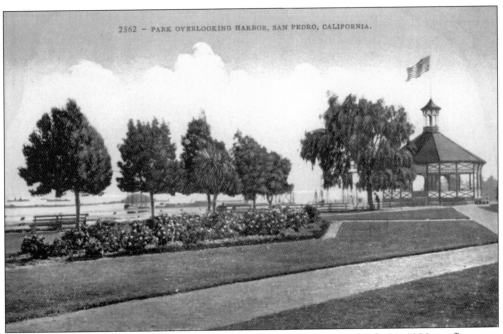

2562 - PARK OVERLOOKING HARBOR, SAN PEDRO, CALIFORNIA.

This photograph postcard, *c.* 1910, displays Plaza Park, which opened July 31, 1889, on five acres donated by Roman Sepulveda. The strip of land was between today's Harbor Boulevard and Beacon Street and from Seventh to Fourteenth Streets. The pavilion, at right, was completed by 1892, and many concerts were performed there.

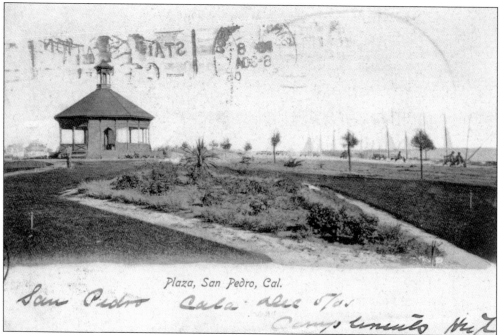

Plaza, San Pedro, Cal.

The smudgy part of the sky in this photograph postcard is due to the ink from another postcard that was still wet when postmarked in "05." The reverse image can be seen when it touched the front of this card mailed in December 1905. In August of that year, the octagonal building at Plaza Park was moved to a new site on Beacon Street between Ninth and Tenth Streets to make room for the new Carnegie Library that was going to be built.

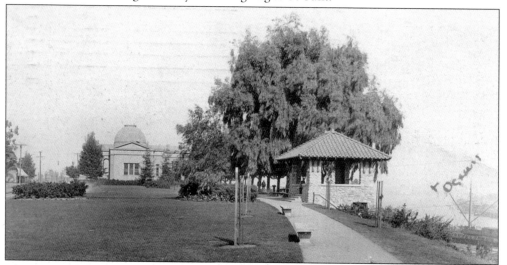

This *c.* 1918 view shows the domed Carnegie Library that now occupies the original site of the octagonal plaza pavilion before it was moved. The wooden pavilion was demolished and stone observation pergolas were built to overlook the waterfront. Not only is the scene picture perfect, but the message on the card indicates that life in San Pedro wasn't too bad either. It reads, "Dear Babe and All, Why don't you write? [sic] Have been looking for a letter. This scene is only two blocks from my house. We like it fine here and intend to stay as long as the wages are good. Write when you can Love to all. Your loving sister Hazel Mailed Feb. 12, 1918."

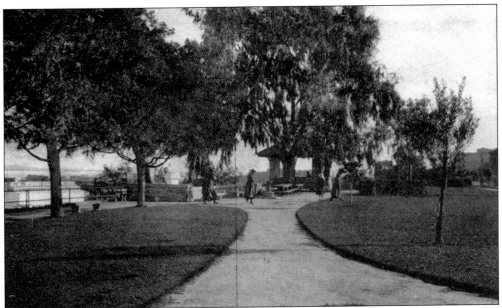

A picturesque view of Plaza Park where the alluring beauty of strolling in the park above the harbor, while gazing at the ships coming and going, is apparent. A serene path runs through the park as one looks towards the waterfront and harbor.

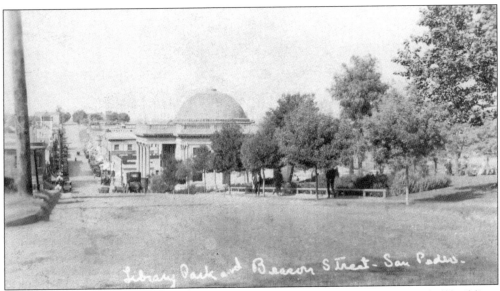

A 1915 photograph postcard view looks north on Beacon Street to the domed city hall building, built in 1906, and Plaza Park, once called Library Park, in the right foreground. The street is now paved and automobiles have replaced the horse-and-buggy that dominated this street only a decade before this photograph.

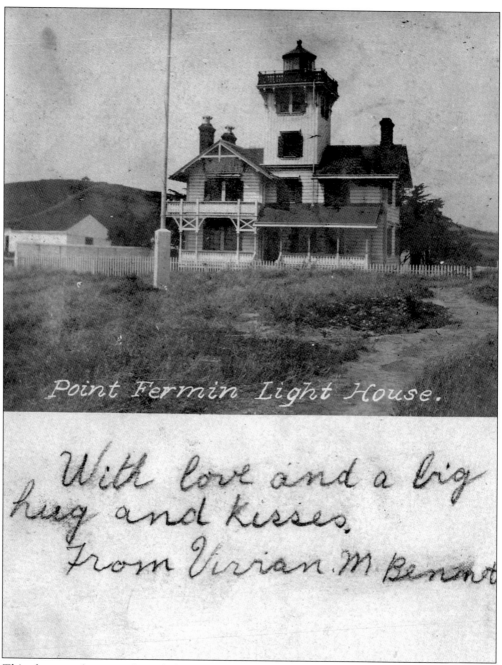

Point Fermin Light House.

With love and a big hug and kisses. From Vivian M Bennett

This photograph postcard, mailed in 1907, reveals a quality, but limited, message by the sender and shows the historic lighthouse sitting on a rather desolate, wind-swept point of land. The Point Fermin Lighthouse was built of redwoods shipped from Northern California. The fourth-order Fresnel lens, ordered by the United States Lighthouse Service, was shipped around Cape Horn from France for installation in 1874. In 1898, a petroleum vapor incandescent lamp (with its 2,100 candlepower light) was installed, and in 1925, a 6,600-candlepower electric light replaced the petroleum lamp. This operated until 1941, when all coastal lights were extinguished due to the U.S. entrance in World War II.

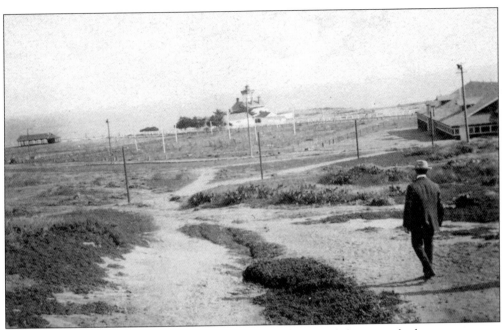

This *c.* 1908 photograph postcard shows the Point Fermin Lighthouse as the lone structure at the point and the absence of trees. It also documents the existence of Peck's Pavilion to the west of the lighthouse. Peck's Pavilion was painted green with white trim and had a bright red roof. It was built by George Peck at the western end of Point Fermin to enhance the promotion of his ocean-view subdivision. In the right foreground is a man walking towards the Point Fermin Lighthouse, which sits on the bluffs of Point Fermin.

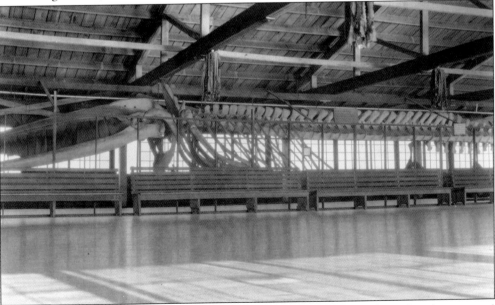

This *c.* 1924 postcard depicts the inside of Peck's Pavilion, which was located at the west end of what is now Point Fermin Park. There is the skeleton of a whale hanging from the ceiling. The building was mainly used as a roller rink and boxing arena, and Sunday dances were also a feature at this popular entertainment center.

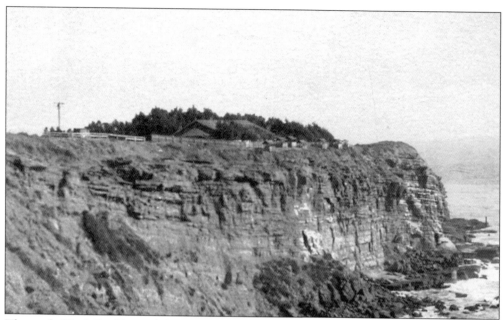

The roof of Peck Pavilion and the parklands, developed by George Peck, stand out prominently while sitting on top of the Point Fermin Palisades overlooking the ocean.

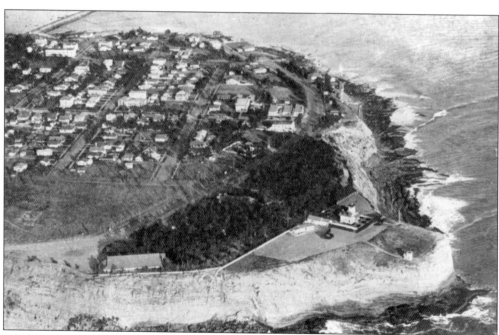

This is a rare aerial view of Point Fermin with the Point Fermin Lighthouse, in the right foreground, surrounded by residences in 1924. In the left foreground are the roof of Peck's Pavilion and the tree-covered area of Peck's Park, later to become Point Fermin Park. Above the park is the curved road of Paseo del Mar connecting to Pacific Avenue. This portion of the point was damaged due to land sinking in the 1930s and became known as Sunken City.

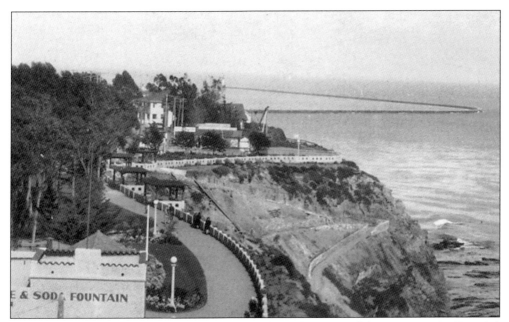

& SODA FOUNTAIN

Further to the edge of Point Fermin, looking east from the tower of the Point Firmin (Fermin) Lighthouse, some of the exclusive and fine homes that resided there in 1932 can be seen. This area is past the café, in the right foreground, to the part of Point Fermin neighborhood that was there until the 1940s. The café building is the only surviving structure besides the lighthouse. All of the other buildings were moved due to the land sinking.

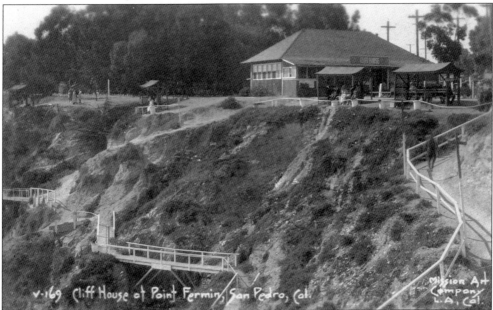

This 1930s image shows the Cliff House above a trail that leads down to the ocean and rocky beach of Point Fermin. Note the famed Point Fermin Park wall is not yet built to the edge of the cliffs around Point Fermin. The ocean trail was well traveled by visitors, even in their long skirts and dress pants. Today all that remains are broken segments of the trail and the street after the land sinking in the 1940s. (Mission Arts Company.)

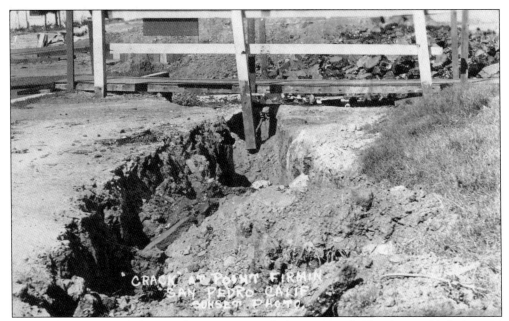

This postcard was mailed September 15, 1929, with the message, "What do you think about it? Earthquake September 13." This was the first year a few cracks began to appear on the streets of Paseo del Mar and Carolina Place and, like the writer of this card, many people unknowingly attributed the movement to earthquakes.

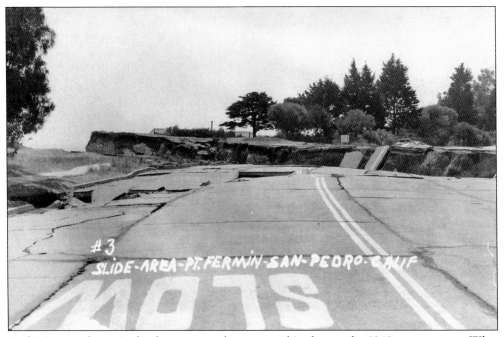

In this image, the major land movement that occurred in the area by 1940 was apparent. What started in 1929 became a slow enough process to allow most of the homes in this area to be moved to other locations before being damaged. This "SLOW" warning on the street is an appropriate message for the movement of the pavement.

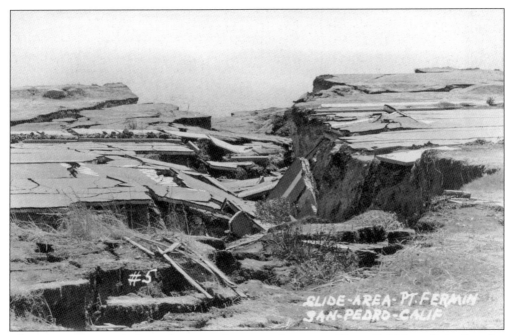

This 1940s photograph shows the severe damage to the street of Paseo Del Mar at Point Fermin. It once had fine family homes, tracks for streetcars, and the Point Fermin Hotel. As sinkage slowly increased, residents made plans to move their homes or move away. Later the area of "Sunken City" would become an abandoned, fenced-off area.

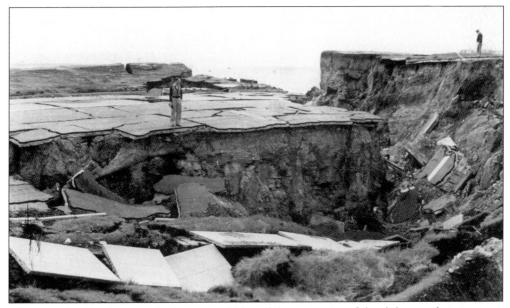

The scene in this photograph gives a good idea of the enormity of the slide area that was once entirely connected. Wave erosion cut away at the moist, soft rock bed underlying the coastal bluffs. This led to the area breaking into numerous, small blocks, which caused the land to sink. The Point Fermin landslide is one of the most dramatic and best textbook examples of what geologists term "slump."

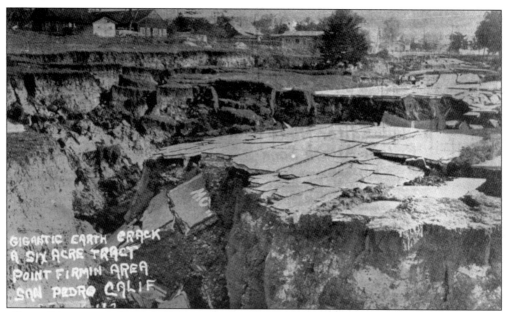

The well-known Sunken City is captured in this photograph of the six-acre slide area around 1950. Over the years, it had to be fenced off to prevent people from entering the dangerous and unpredictable area. However, it has become a popular "no trespassing" area to explore and photograph with all the jumbled rolling land and its tilting palm trees, crooked sidewalks, broken road sections, and chimney foundations.

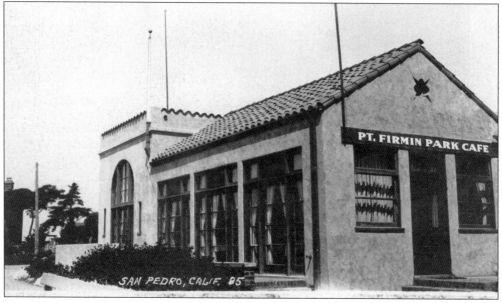

Here is the Mediterranean-style Point Firmin Park Café as it looked around 1927. It is located just east of the lighthouse in Point Fermin Park. Today the building is no longer a café but serves as the head office of the American Cetacean Society and a community meeting room.

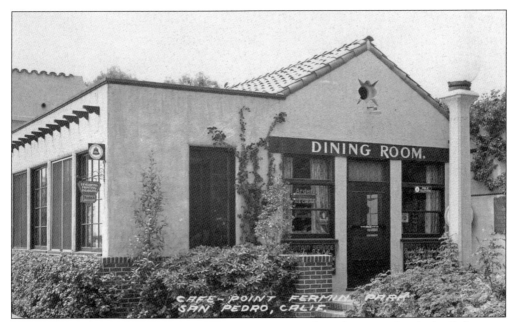

The Point Fermin Park Café, located in Point Fermin Park in the 1930s, has had a little name change and the building has been enlarged. It was always a popular place for lunch and dinner. Now they advertise the addition of Arden Ice Cream, a public telephone, and Kodak film.

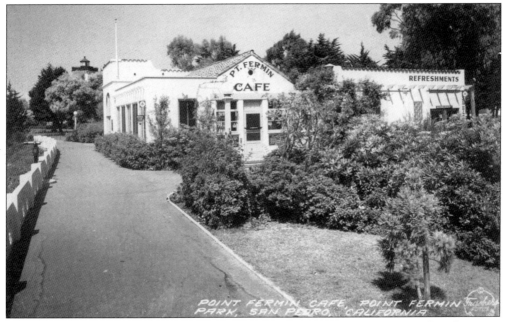

Known as the Pt. Fermin Café in this 1940s photograph, the view provides a peak at the tower of the lighthouse in the distance behind the café. This postcard also has a message from a patron, which hints at a simpler time, "Dear folks Sitting here with coffee & pie & thinking of you. Fritz promises a long letter soon." (Frashers Fotos.)

Point Fermin Park was purchased from George Peck for $93,000 in 1923. It began with the original nine acres and was gradually increased over time, including the lighthouse property. In the early years, it seems to have been known as Peck's Park probably because it was well landscaped and was used as a center from which Peck conducted sales of his Point Fermin properties. It boasted a boxing arena, a roller rink, and a dance area known as Peck's Pavilion, which was demolished in 1925. (Mission Arts Company.)

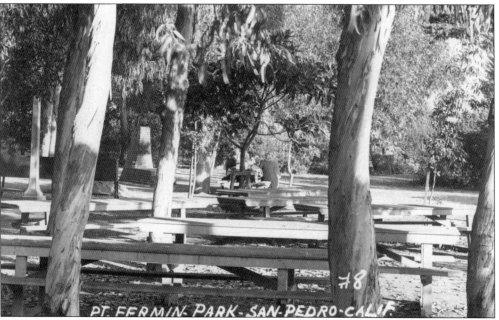

This 1940s postcard shows Point Fermin Park as a perfect site for family picnics with its many picnic tables among the eucalyptus trees. This also demonstrated how thick the trees were in the earlier days. The park boasts a band shell where there are still music concerts and even free Shakespeare plays during the summer.

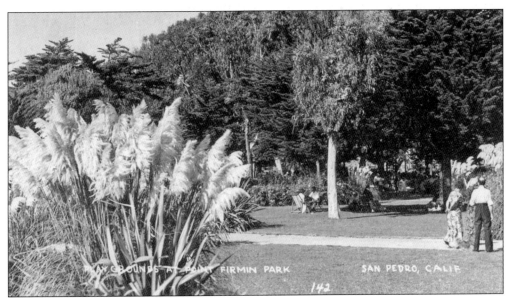

This *c.* 1950 photograph postcard finds a couple admiring the foliage in Point Fermin Park. With its 37 beautifully landscaped acres of trees, shaded lawns, colorful gardens, and refreshing winds, there are visitors constantly to this park located at the southern most point in the city of Los Angeles. The scenic park also has several picnic/barbecue areas, a playground, and an amphitheater and is home to the Point Fermin Lighthouse, built in 1874 and now a museum.

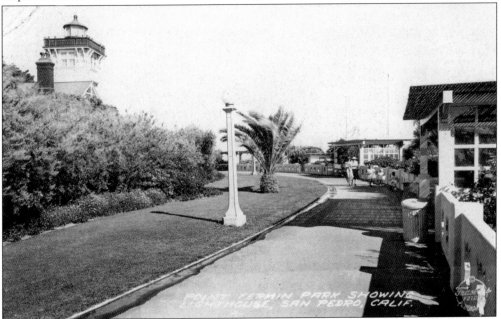

This scene from a *c.* 1940 photograph postcard shows Point Fermin Park with its sheltered pergolas and promenade along the edge of the Pacific Ocean in front of the Point Fermin Lighthouse. The vantage point atop the rugged bluffs presents a breathtaking view of the Southern California coast toward Santa Catalina Island, 26 miles away. The light was still functioning at this time before World War II. Today many people still take the same strolls along the coast. The Point Fermin Lighthouse has been rehabilitated and is open to the public as a museum.

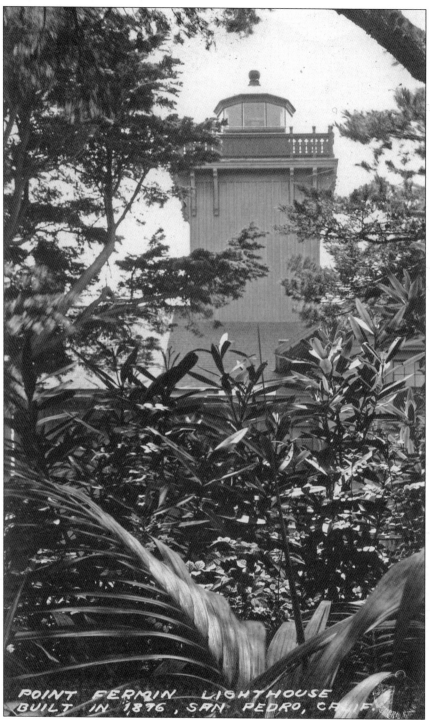

POINT FERMIN LIGHTHOUSE
BUILT IN 1876, SAN PEDRO, CALIF.

In this *c.* 1925 postcard, the regal tower of the Point Fermin Lighthouse pokes through the foliage surrounding the lighthouse and encompassing Point Fermin Park. The Point Fermin Lighthouse was built in 1874 upon the relentless persuasions of Phineas Banning to Congress. It majestically sits atop the cliffs of Point Fermin as a guide to ships at sea.

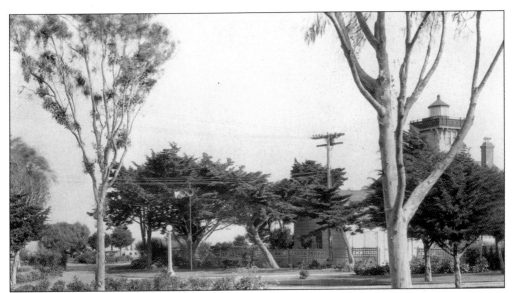

A historic Victorian, Stick-style lighthouse, Point Fermin was surrounded by colorful well-trimmed flower gardens throughout the park. This photograph shows a glimpse of the lighthouse tower and chimneys that were first commissioned on December 15, 1874, by the first lighthouse keepers, sisters Mary and Ella Smith. Will and Martha Austin tended the light from 1917 until 1925, when they both died. The last official lighthouse keepers were their daughters, Thelma and Juanita Austin. The photograph also catches a part of the unique fence built by Mr. Woodman, a friend and neighbor of the Austins.

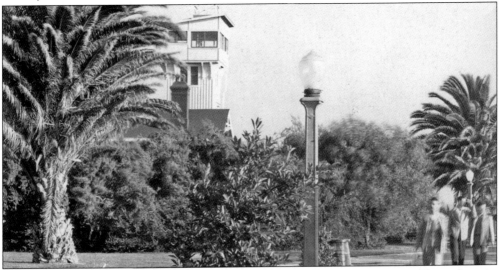

The Point Fermin Lighthouse lantern room (top of tower) looks strangely different from its original 1874 architectural design in this c. 1950 photograph postcard because it was removed by the military immediately following December 7, 1941. It was done to install an early type of radar in the tower with two navy sailors to be lookouts on the coast. The boxed-in structure atop the lighthouse was referred to as the "Chicken Coop" by locals, since it mirrored many chicken coops in their backyards. The lantern room remained that way for 33 years. Then, in 1974, two men, John Olguin and Bill Olesen, rebuilt it. They were able to complete the restoration in time for the 100th birthday celebration of the Point Fermin Lighthouse.

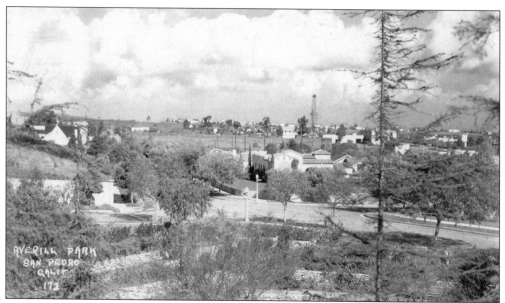

This is the view from the northeast corner of Averill Park at Averill Park Drive and Weymouth Avenue. The park is in the Vista del Oro section of San Pedro and shows a smattering of homes to the north. At a time with fewer houses and more land, the message on the back of the postcard sounds of less stressful times when it was mailed May 1, 1949, "Another nice day coming up. Agnes & Earl have gone grocery shopping and I'm writing cards. We are going to Terminal Island later today having a good time here but it is short. Edith."

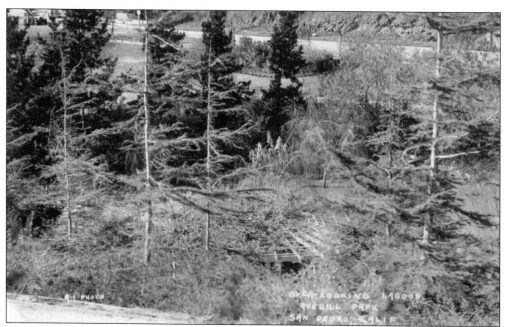

Looking north from one side of the gully to the other, this c. 1930 photograph postcard shows Averill Park Drive at the top of the photograph, which borders the northernmost edge of the park. The developers of Averill Park took advantage of the natural gully in the canyon running down the hillside through this area known as Stingaree Gulch.

This photograph, taken around 1930, gives a different view of Averill Park. The land, located at the intersections of Weymouth Avenue, Averill Park Drive, and Thirteenth Street, that makes up Averill Park was donated to the City of Los Angeles in 1920 by the Averill Weymouth Company. All the parks in San Pedro reflect the early developer's sense of community, which was apparent in their spirit of giving. Like many of the parks in San Pedro, most are donated lands thanks to the early developers who had a vision for the community.

A person can get a good idea of the hilly nature of Averill Park from this c. 1930 photograph postcard. It shows how Averill Canyon cuts across the beautiful, lush, 10-acre park area with expanses of lawn on the hillsides and the brush-covered creek at the base of the gully. Herbert O. Averill developed the surrounding Vista del Oro residential area, with its Spanish-style homes, along with his brother-in-law Weymouth.

The bridge at Averill Park, seen here around 1930, is still the site today for many brides and grooms posing for their wedding pictures. With its meandering streams and ponds and surrounding hills covered with lush vegetation, Averill Park provides great scenery for painters and photographers, especially wedding photographs.

This 1946 photograph postcard captures the scenic Averill Park with its creek meandering down the gully section of the park covered with trees. Children of every generation have spent endless hours trying to catch the elusive crawdads in the cascading waters of the Averill Park waterfalls and ponds. The park has trails that leisurely follow the creek, with pergolas dotting the landscape for family picnics and outings.

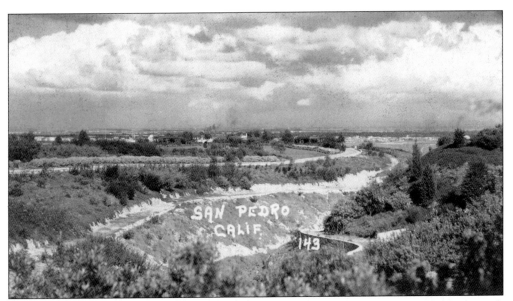

A sweeping scene of the area known today as Peck's Park is depicted in this 1940s photograph postcard. George Huntington Peck, an early real estate developer and benefactor in San Pedro, donated land in 1929, and it became the largest park in town. More acres added over the next eight years by Peck's donations extended the park and its facilities. In 1940, Peck died and bequeathed $1.75 million for the parks of San Pedro.

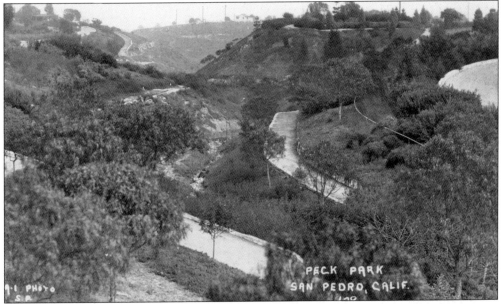

This 1940s photograph postcard overlooks the canyon section of Peck Park and the little roads neatly lined with Palos Verdes stones that meander through the park. The rolling hills of Peck Park are divided by a canyon that was said to be the reason Peck felt he couldn't develop the land for housing lots. Along with the land for Peck Park, George Peck also donated the lands that became separate parks in town named after his daughters: Alma, which is 2.4 acres of park near Twenty-first and Meyler Streets; Leland, which comprises 16.97 acres of park on the west side of north Gaffey Street; and Rena, a small park on Summerland Street.

A *c.* 1930s image shows the abundance of trees on what is now Fifth Street looking west up Gaffey Canyon just under the Bandini Bridge between La Alameda and Sixth Streets. John T. Gaffey and his wife, Arcadia Bandini, owned this area of land known as La Rambla. The canyon still has a lot of these original trees planted by Gaffey in the canyon on the grounds that surround today's YMCA.

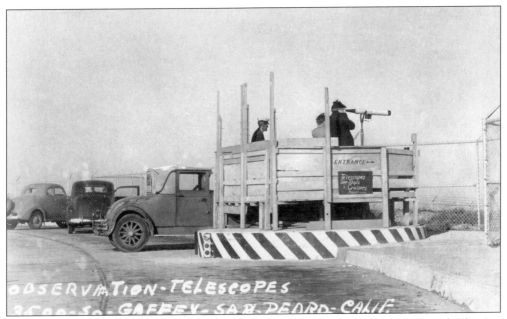

Lookout Point on Gaffey Street near Thirty-fifth Street is seen in this *c.* 1935 postcard. The sign on the side of the viewing platform reads, "Telescopes See—Ships, & Cruisers, Mountains." In 1958–1959, these 1.42 acres were saved from pending commercial use when it became part of Los Angeles Recreation and Parks Department of the City of Los Angeles.

Entering San Pedro in the 1960s, before the freeway "emptied" onto Gaffey, this is the scene along North Gaffey Street as it passes Leland Park. This 1960s image shows a portion of the hillside of Leland Park looking south. Note how the hills are covered in blooming flowers and have neatly manicured grass along the street. (Western Publication and Novelty Company.)

A message on the reverse side of this card reads, "Pictured are a few of the six hundred flags flown on Memorial Day, Armed Forces Day, Flag Day and the Fourth of July. These flags have been given into our care by the surviving families of deceased Veterans. Signed, Green Hill Memorial Park." Green Hills opened this cemetery to service the South Bay in 1948 after World War II. San Pedro's first and only graveyard is Harbor View Park at Grand Avenue and Twenty-fourth Street.

This c. 1930s view from the northwest corner of Averill Park looks towards the very sparsely populated hillside of Palos Verdes hills. Today the hillsides are covered with homes from the city of San Pedro and Rancho Palos Verdes. It was mostly these that encompassed the more than 800 acres that Averill purchased from Rudecinda Florencia Sepulveda de Dodson. It was Horace L. Averill, Dr. George Averill, and their brother-in-law H. L. Weymouth who purchased the land and formed the company. These properties would become a section of San Pedro known as Vista del Oro (View of Gold). However, in 1924, as H. L. Averill sold most of his interest, a third brother, H. O. Averill, undertook the development of the tract, from the planting of trees to plotting of properties with the aesthetic help of their mother.

Six

MILITARY

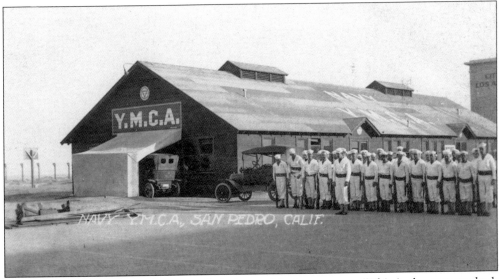

This May 29, 1918, postcard was mailed along with the message, "This is the way we look when we are drilling on the grounds here the uniforms white with leggins." The navy YMCA building can be seen next to the harbor's Warehouse No. 1, at far right, located on the Huntington Concession Municipal Pier No. 1.

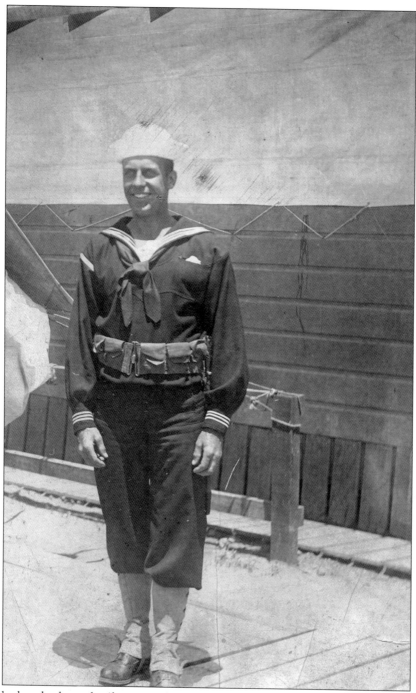

A proud, sharply dressed sailor poses for this picture in 1918. The message written on this postcard reads, "U.S. Submarine Base San Pedro—Am still here but can expect to leave today. Just within a few minutes of the time we expected to shove off last Saturday, one of our engines had a breakdown. The next day being Sunday and next after that being Labor Day we were unable to secure repair parts any earlier. P. S. They don't sensor our letters here or at San Diego."

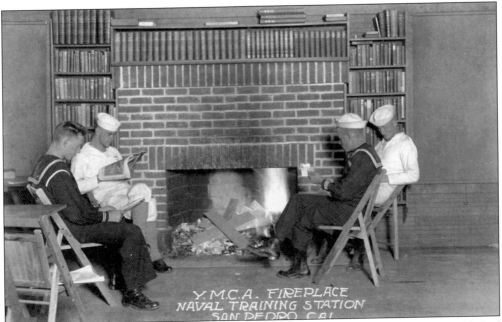

This postcard was mailed July 30, 1918, which was the same year the YMCA was established for navy and army personnel stationed in San Pedro. Sitting in front of the fireplace, four sailors are relaxing and reading. The message partially states, "My Dear Alice, I did not receive an answer from you I hope you have not forgot your old friend Mim."

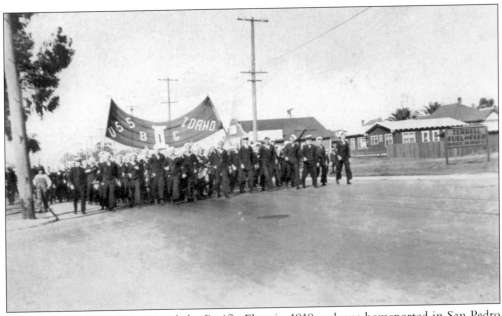

The battleship USS *Idaho* joined the Pacific Fleet in 1919 and was homeported in San Pedro during the 1920s and 1930s. Sailors from the battleship parade down Pacific Avenue carrying a banner with their ship's name on it. Early businesses and homes are in the background.

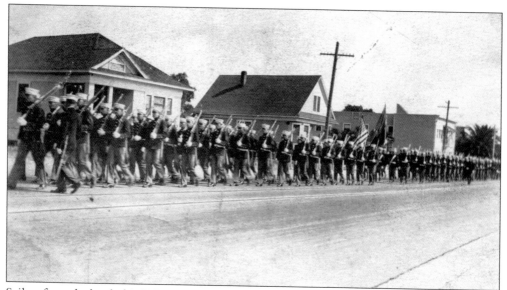

Sailors from the battleship USS *Mississippi* march in formation down Fourteenth Street between Centre and Mesa Streets in 1919. The *Mississippi* was just one of several battleships assigned to the Pacific Fleet and homeported in San Pedro. The *Mississippi* was commissioned on December 15, 1917, and left the Atlantic for the West Coast on July 19, 1919.

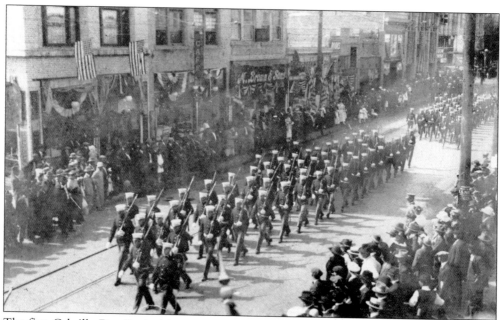

The first Cabrillo Day Festival in town was on October 16, 1920. As usual, San Pedrans went all out celebrating the event by greeting the troops from sidewalks as they marched in formation in downtown San Pedro. Earlier the same day, there was a ceremonial opening of the newly finished Cerritos Channel connecting the Los Angeles and Long Beach Harbors.

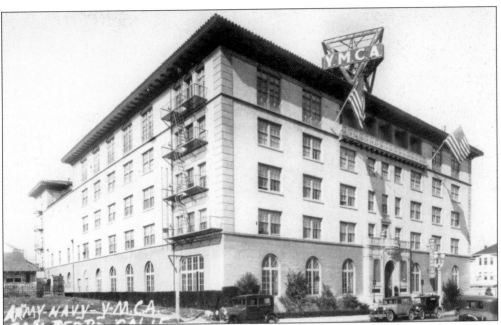

Located on Beacon Street, the landmark army and navy YMCA building was constructed in 1926. Its mission was to provide athletic and social activities for military personnel who were in town. Celebrities such as Bob Hope and Lucille Ball stopped here to entertain troops on their way overseas. This five-story Spanish Colonial Revival–style structure sits on the bluff overlooking the harbor's main channel.

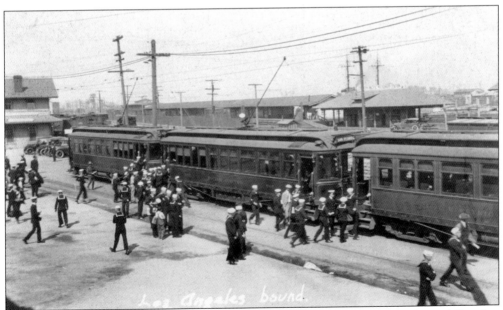

In the late 1910s, a newspaper boy (center) is selling his papers to a few sailors while other sailors board the Pacific Electric Red Cars bound for Los Angeles or Long Beach. The streetcar stop was located next to the navy landing at the end of Fifth Street on the waterfront in San Pedro.

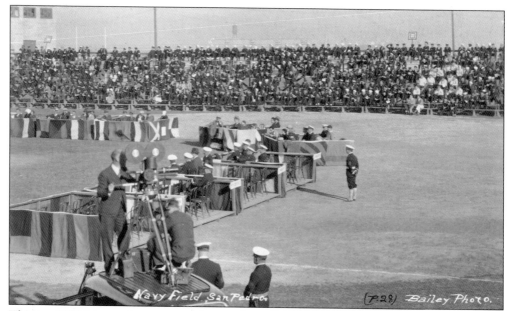

This is a 1937 image of an event at the navy's Trona Field, a location for many sport activities in San Pedro. The large crowd in the stands and the people in the VIP boxes are watching the activity on the field as the cameraman looks in the opposite direction. The majority of the people in the stands are sailors with only a few civilians and army personnel. (Bailey.)

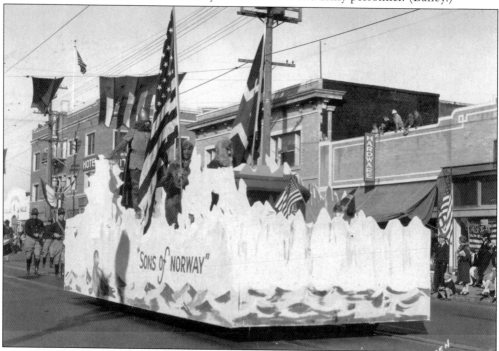

This photograph shows the celebration of the Armistice Day Parade on Pacific Avenue in 1928. Three men ride the "Sons of Norway" float that is being followed by the U.S. Army Band. One man is wearing a Viking-type outfit and the other two are sporting winter fur outfits. Onlookers watch from rooftops of buildings along Pacific Avenue and sidewalk curbs.

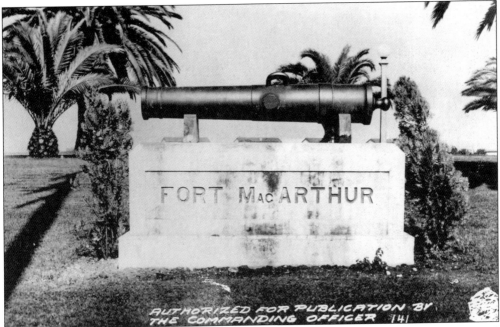

This sign, with a cannon atop of it, is named Fort MacArthur in honor of Lieutenant General MacArthur, a Medal of Honor recipient and governor of the Philippines in 1914. Gen. Arthur MacArthur was also the father of the future General of the Army, Douglas MacArthur, of World War II notoriety. (Frashers Foto.)

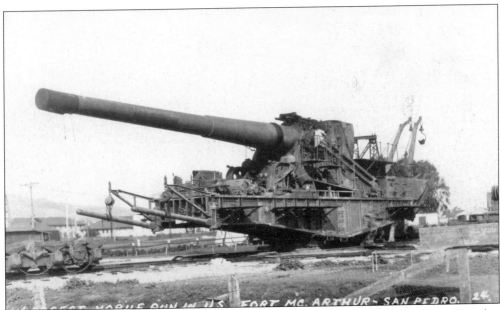

In 1925, this was one of the two 14-inch, 365-ton railroad guns, also called Big Berthas, that were employed on the Middle Reservation. Practice firing shattered many local windows, and by 1928, after public protest, no further firing was permitted at Fort MacArthur.

The army band is playing on the parade grounds in this 1926 image on the Middle Reservation at Fort MacArthur. Just above the tuba player on the right, one of the Big Bertha, 14-inch railroad guns can barely be seen in the background. (Frashers Foto.)

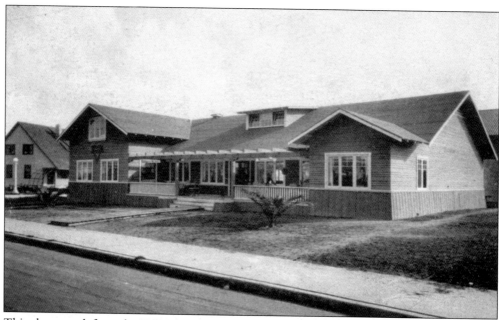

This photograph from the 1920s shows the new Service Club located on the Middle Reservation at Fort MacArthur, presently called the Officer's Club. The area occupied by the fort has been a government reservation since the mid–19th century and part of the original 500 *varas* square of Mexican Californian times. (Theo Sohmer.)

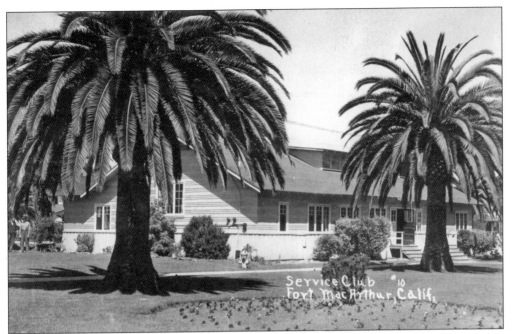

This is another view of the Service Club at Fort MacArthur as it looked in the 1940s. Continuing through the 1950s, the fort served as an induction and separation center for the army.

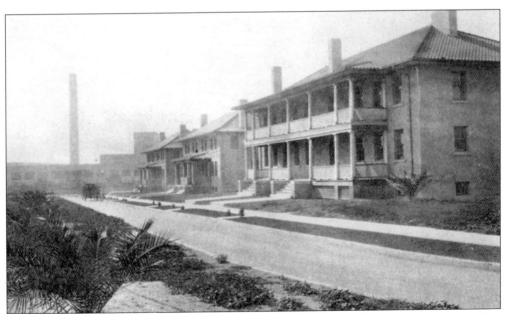

Here is inside of Fort MacArthur and the housing area of officer's row in the 1920s, which was located southwest of the parade grounds. In the distance is the historic old Trona plant. (Theo Sohmer.)

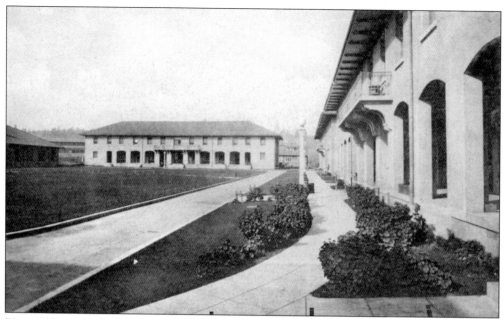

Pictured here are the barracks at Fort MacArthur, located around the quad area on the Middle Reservation in the 1920s. The California National Guard trained here, and the Civilian Conservation Corps also occupied some of the housing facilities. (Theo Shomer.)

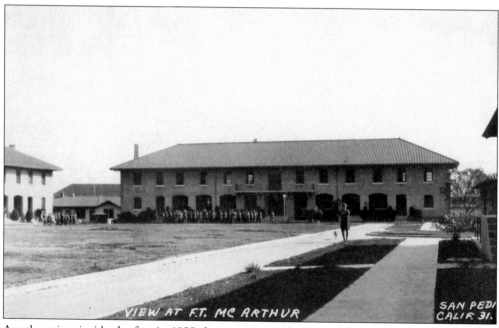

Another view inside the fort in 1925 shows a group of soldiers standing in formation in front of their barracks located around the quad area of the Middle Reservation at Fort MacArthur. During World War I, the fort served as a training and staging area for the army until departing for the European theater.

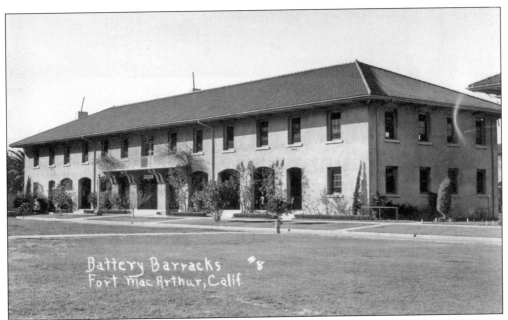

Guarding the harbor was the reason for establishing Fort MacArthur in 1914 at San Pedro. Seen here is a view of the coastal artillery battery barracks in the 1930s, located next to the area later called the Patton Quad.

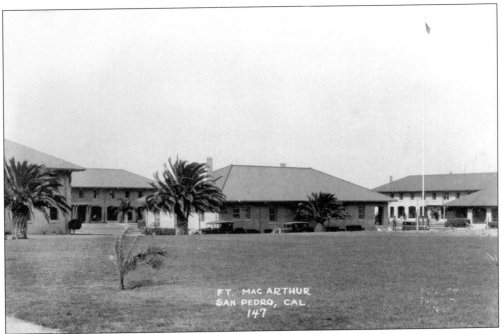

This is a 1930s image of several of the buildings that are located on the Middle Reservation at Fort MacArthur. The construction of the housing and headquarters buildings were in the Mission Revival and California Craftsman architectural styles.

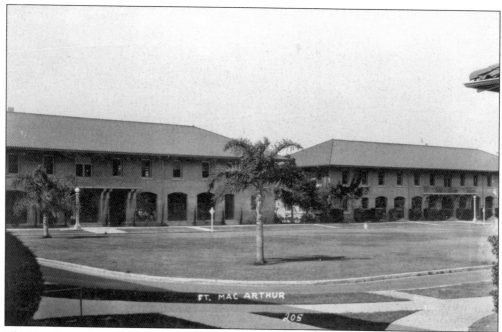

These are barracks located around the quad area at Fort MacArthur in the 1930s. After World War II, the fort's mission changed to a major training center for army reservists as well as being an antiaircraft missile site.

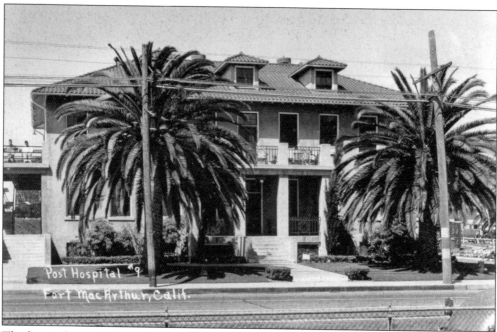

The hospital at Fort MacArthur was located on the west side of Pacific Avenue, as seen here in 1933. To the left are two patients sitting on the second-floor balcony. The building was demolished in 1982, and the government land was sold.

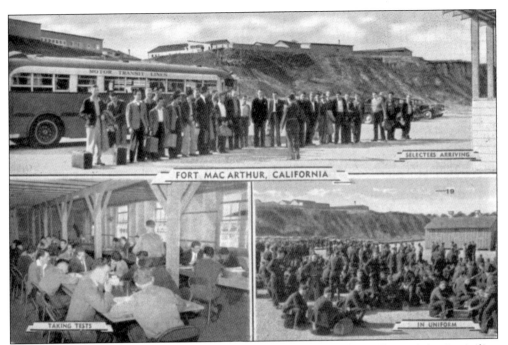

A postcard mailed in May 28, 1942, depicts the life of a new inductee. After arriving in civilian clothes at Fort MacArthur for induction into the U.S. Army, these men pass through a number of tests to ascertain the branch of service for which they are best fitted. Later they are outfitted with regulation uniforms and wait assignment to one of the training camps.

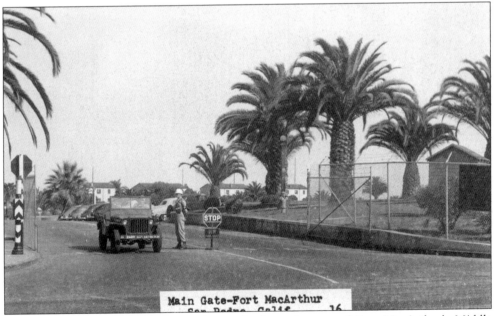

A lone MP, or military police (man), guards the main gate of Fort MacArthur's Middle Reservation in the 1950s. In 1982, the air force officially took over control of the fort from the U.S. Army, and the air police now guard the entrance.

This is a wonderful, whimsical, hand-drawn postcard by an unknown artist from the 1920s with the title "The Letter To Dad." With the image of a young sailor in the center, surrounded by lovely young ladies, the message sent home reads, "San Pedro Calif. Dear Dad, We are so busy we haven't time for anything but duty on the ship." The note fails to say anything about the infamous bars and red-light district on Beacon Street.

"THE LETTER TO DAD"

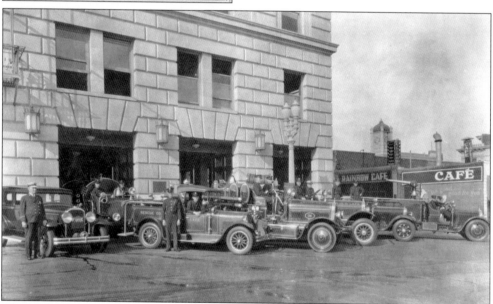

In this *c.* 1928 view, the firemen, dressed in their best uniforms, have an impressive array of their vehicles and trucks parked in front of their new station. The San Pedro Fire Station was located on the Harbor Boulevard side of the municipal building. In the background, on the right side of this building, the clock tower of the Bank of San Pedro can be seen along with a few other businesses.

BIBLIOGRAPHY

Beck, Robert F., Timothy T. Lemm, and Sandra Radmilovich. "San Pedro: The First 100 Years," *News-Pilot/The Daily Breeze* (Copley Los Angeles Newspapers), March 24, 1988.

Beigel, Harvey M. *Battleship Country The Fleet at San Pedro-Long Beach, California: 1919–1940.* Missoula, MT: Pictorial Histories Publishing Company, 1983.

Kolumbic, George, and others. "I Remember San Pedro About the People of San Pedro," *News-Pilot/The Daily Breeze* (Copley Los Angles Newspapers), March 30, 1989.

Mandia, Peter, Col. Loe Draper, Arthur Almedia, Flora Twyman Baker, Oliver Vickery, Col. Adna G. Clarke, Maj. David Gustafson, Donald Young, and Tom Coulter. "Fort MacArthur." *San Pedro Bay Historical Society Shoreline.* November 1980.

Schultz, Kathryn. "San Pedro's Public Elementary Schools." *San Pedro Bay Historical Society Shoreline.* October 1985.

Silka, Henry P. *San Pedro A Pictorial History Updated Through 1990.* San Pedro Bay Historical Society, 1993.

Vickery, Oliver. *Harbor Heritage Tales of the Harbor Area of Los Angeles, California.* An Authors Book Company Publication, 1979.

Wayne, Maud, Harry G. Hall, Vivian Jungferman, Sam Domancich, Sharon K. Ogamuri, Bill Muller, Irene Bracco, Anne Hochreich, Meredith Ludwig, Rev. Arthur Bartlett, Flora Twyman Baker, Joseph M. Maardesich, John Olgiun, Dorothy Woodruff, Gerogianna Wood Buzzini, Francesca Giacalone, Ruth Dahlquist Thayer, Mel Bobich, James J. Reani, Barbara Fields Trani, Mitchell Mardesich, and Joseph M. Mardesich Jr. "One Hundred Years of San Pedro High School." *San Pedro Bay Historical Society Shoreline.* April 2003.

Across America, People are Discovering Something Wonderful. *Their Heritage.*

Arcadia Publishing is the leading local history publisher in the United States. With more than 3,000 titles in print and hundreds of new titles released every year, Arcadia has extensive specialized experience chronicling the history of communities and celebrating America's hidden stories, bringing to life the people, places, and events from the past. To discover the history of other communities across the nation, please visit:

www.arcadiapublishing.com

Customized search tools allow you to find regional history books about the town where you grew up, the cities where your friends and family live, the town where your parents met, or even that retirement spot you've been dreaming about.